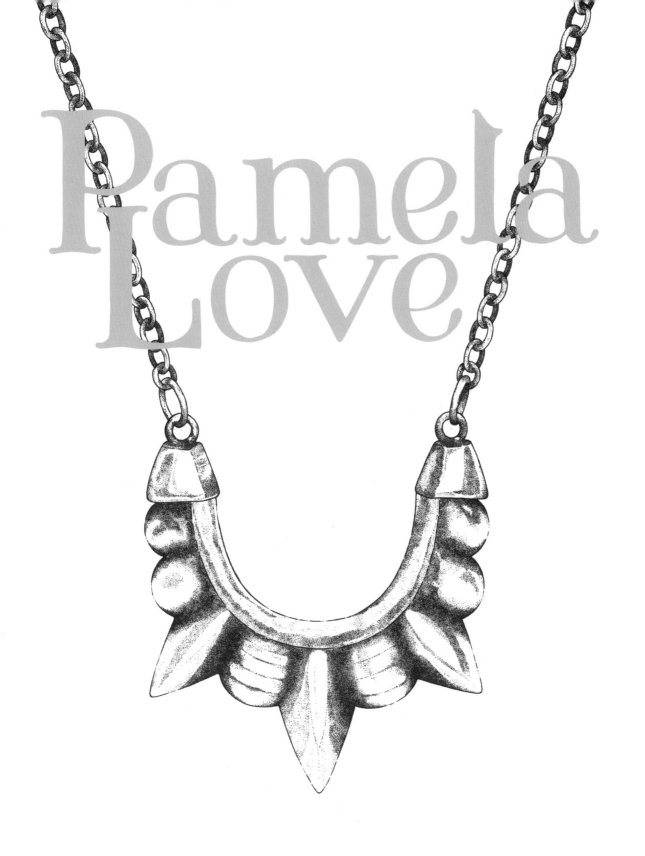

Pamela Love

MUSES & MANIFESTATIONS

Pamela Love

RIZZOLI
NEW YORK

New York · Paris · London · Milan

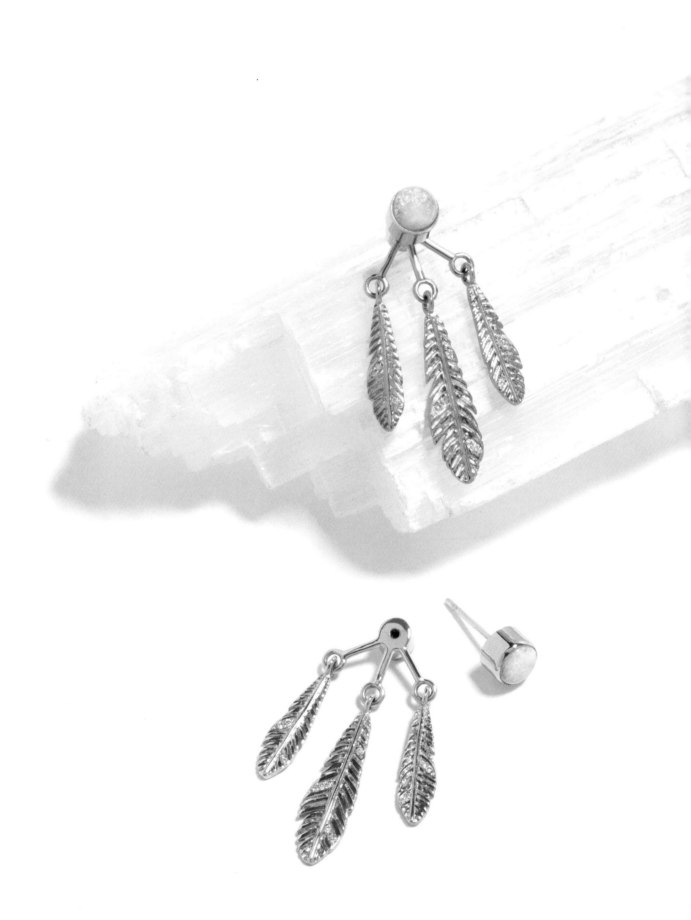

Open to me, so that I may open.

Provide me with your inspiration.

So that I may see mine.

—Rumi

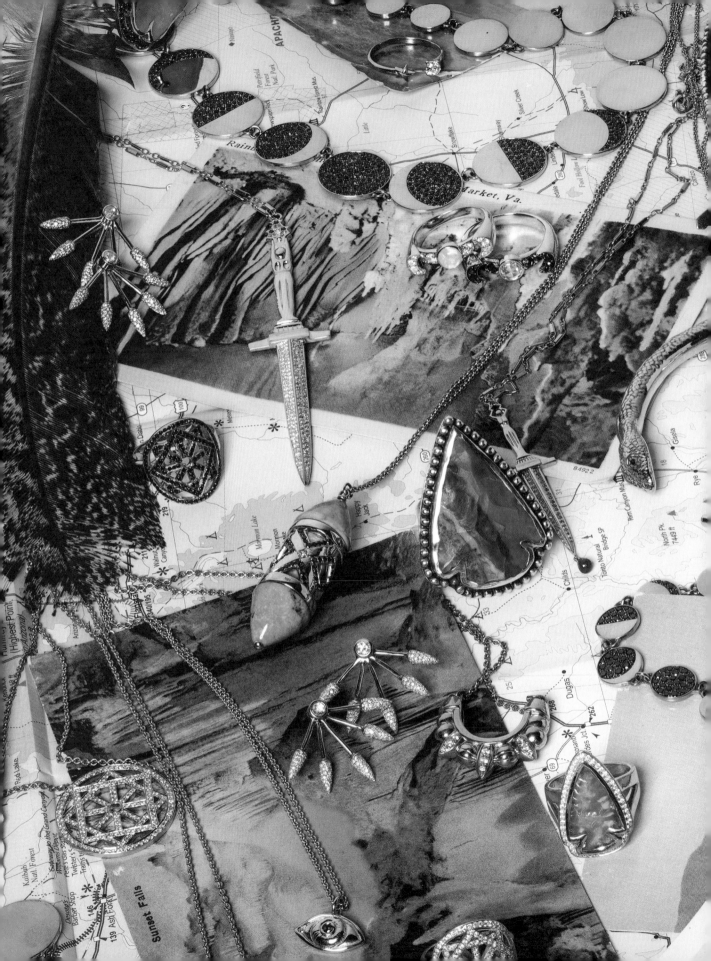

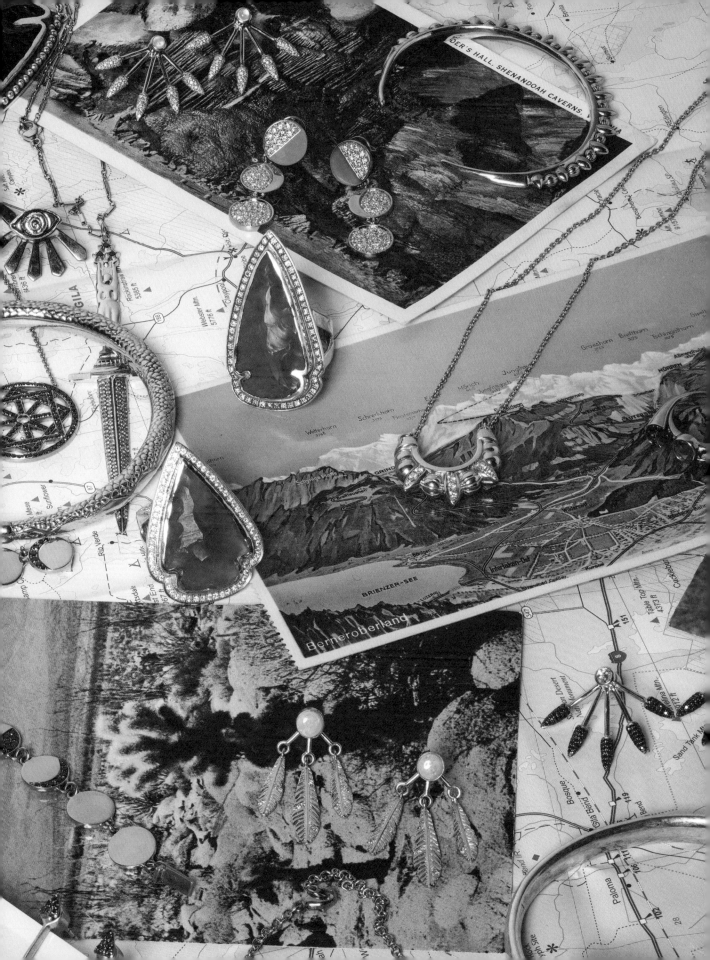

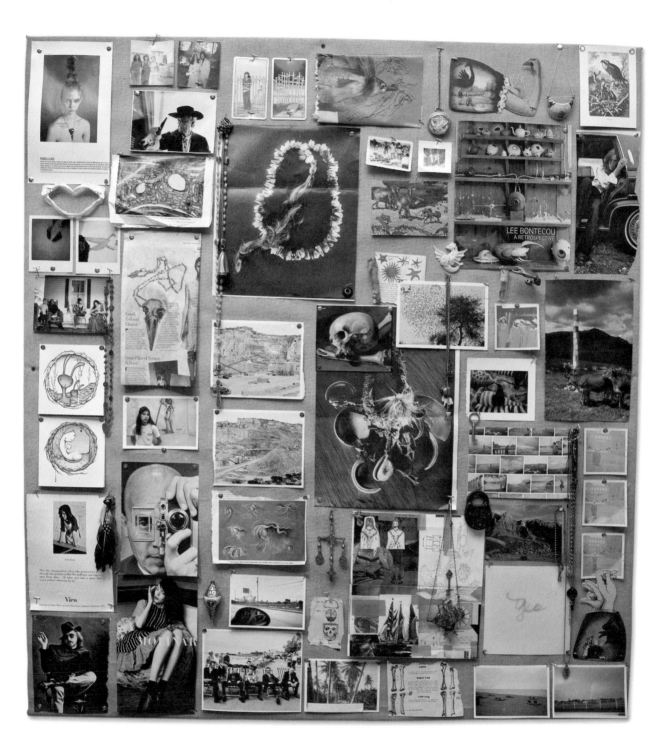

Introduction
Ray Siegal

The words "inspiration" and "muse" might be some of the most overused, but for good reason. What drives us and inspires us—that journey—can be as intriguing as the final outcome. While inspiration can come from anywhere and anything, there's a reason why similar destinations, organic landscapes, and pop culture icons are frequently cited sources of creative influence by art and design's most identifiable names. For Pamela Love, the deep well that she draws from ranges from the remarkably obscure to the mundane.

One of the earliest sources of inspiration that she can cite is more memory than muse. She can trace it back to a pair of aquamarine earrings that were gifted to her from her mother, marking an important rite of passage that other ear-pierced girls might also recall: the end of that seemingly eternal six-to-eight= week waiting period, mandated by a Claire's Boutique piercing technician, in which you were forbidden to change out of your first pair of earrings. Once you were in the clear, you could graduate from childish stud post earrings to more mature pairs that dangled. For girls like us, it was as close as we'd get to a ritualistic introduction to womanhood, even if we weren't more than five years old at the time. The holes in our ears were powerful symbols that would become as meaningful as the countless friendship bracelets and beaded necklaces we'd so steadfastly be manufacturing by age ten.

Only a few weeks later, Pamela misplaced one of her aquamarine earrings. In her sorrowful state, she began a search through yards of shag carpeting and vacuum cleaner bags that,

in the end, proved futile. Her self-imposed punishment was to always wear just the one remaining earring in a mismatched set. Surely this could have been deemed an early sign of her gift for trend forecasting, or even a precursor to the leadership qualities for the cult following she'd gain, but at the very least, it marked an interesting evolution of her personality at an early age.

With the exception of that first gift, Pamela surprisingly hated the idea of traditional jewelry, having associated it with the types of mall stores and exchanges that were popular in the part of southern Florida where she grew up. It was enough to make her reject the entire notion of jewelry, until she'd later revisit the power of adornment through its limitless ceremonial processes throughout history.

Her general distaste of jewelry forced her to take matters into her own hands. When she was thirteen, she made her first pieces by melting glittery toothbrushes after she had torn out all of the bristles. She boiled them until they were pliable, bent them to her satisfaction into bracelets, and then piled on as many as one teenage arm could handle.

Pamela's other childhood muses stem from her constant search for other worlds—and the connection that those worlds might have to the body and soul. At age fourteen, when she wasn't busy melting her toothbrushes, she taught herself to read tarot cards. Her preoccupation with the art of tarot attracted her to occult figures like Aleister Crowley, who developed his own version of the cards. She became intrigued by the relationships he had with other historical

occult figures and rock stars like the Rolling Stones. Another early muse, you might say, was her love for the jewelry-making process itself—and again, this reintroduced her to the concept of adornment being crafted, often times by hand, for ceremonial purposes.

Pamela went on to study film at New York University, but by the time she was finished with her senior thesis, she claimed she'd never watch a movie again. It may be worth mentioning that said thesis was inspired by filmmaker–turned–tarot card reader Alejandro Jodorowsky, and that the film's main character was half man and half chair. The story's antagonist had but one fatal flaw: she wore so much tacky jewelry that it weighed her down. Then, during a period of post-college drift, Pamela tested the waters of being a fashion stylist.

While that particular path didn't work out, her longest working relationship was as an assistant to legendary painter Francesco Clemente. Under his tutelage, she became finely tuned to his muses and the world that he constructed through art. He challenged her own inner artist and she began to express herself through, and find solace in, handmaking her own jewelry (this time, with more precious materials than toothbrushes). She learned that he too shared her passion for tarot and these same occult figures. During some of her most difficult times, Pamela found comfort and meaning in Francesco's card readings. She found it to be magical, not coincidental, that all of her artistic heroes read cards. It legitimized some of her more fringe ideas, which, in turn, helped her to address them in a fine art and fashion setting. Her obsessions became beautifully woven throughout, and the meaning behind, much of her work.

Francesco was her first supporter while fashion icons Julia and Carine Roitfeld became her second and third. Julia was beginning her own career in editorial at the time, and had championed features on Pamela's work in both French *Vogue* and *Purple Magazine*. It didn't take long for the rest of the world, and major buyers from major global retailers like Colette, Opening Ceremony, and Barneys New York, to see eye to eye with the Roitfelds' selective taste in jewelry.

Pamela's artistic outlet became a full-time job almost overnight. Her initial collection came together when her father passed away, an event that drew her into the concept of mourning jewelry and its darker occasions. Ignoring the traditional styles that she loathed, her research led her to cultures that celebrated deeply emotional moments with mysteriously dark adornment. Though these symbols were meant to be worn, they had meaning and, in some cases, came steeped in thousands of years of tradition. The beauty of that first collection is that it both honored and connected her to her father.

Pamela continued to work within the context of her collection being a vessel for the places she'd like to go—each piece of jewelry became a metaphorical artifact that she might have collected along the way. One season she is on a journey throughout the American Southwest, and then she links up with the European occultists of the 1920s. Next, she might find herself floating in outer space. But the line that has been drawn through all of her experiences—both real and imagined—is that the jewelry-collecting traveler evolves but remains the same. As outsiders, we can see that her personal stamp is always there. More people

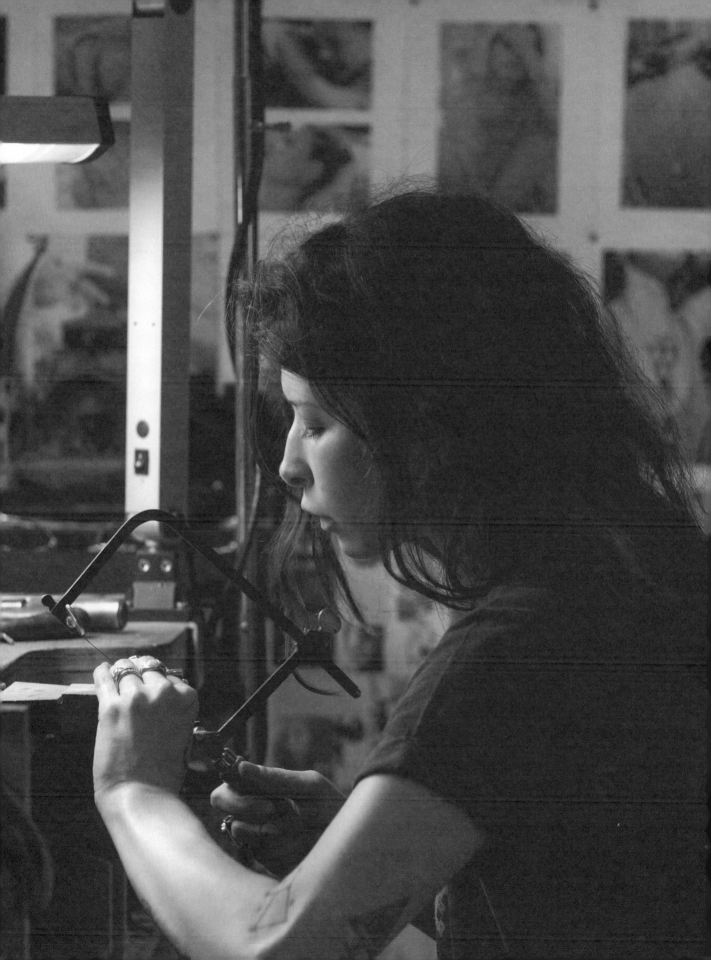

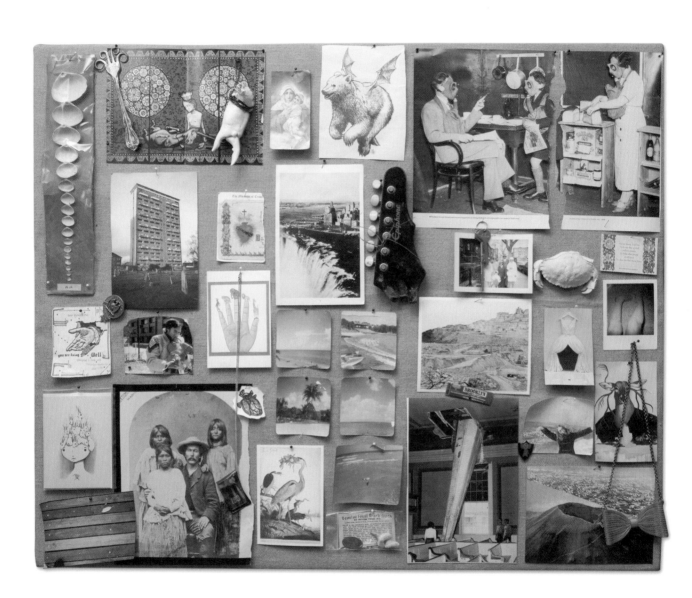

than Pamela could have ever imagined seem to identify with the imaginary world that she has created through jewelry.

In building this vision, she garnered a cult following of those who wanted in on the experience. Whether they knew it or not, Pamela was offering something that other designers in her category (which was much smaller at the time) were not. Her far-from-classic style hinted at something deeper and, at times, more spiritual. She became obsessed by the idea that jewelry could be used as a communicator of magic or an element in mystic rituals. Magic in several forms drew her to the exploration of motifs that would later be repeated throughout much of her work. It became about the weird and the confusing, and the idea that a mere mortal could do something unearthly through his or her own devices. She was essentially leading us away from the idea that earrings, rings, and necklaces had to be classic and made from diamonds and pearls to be pretty—or that they should "dangle." Her movement was about different kinds of traditions, though new to many, that had been around for thousands of years. And her aesthetic speaks to individuals who care about individuality. Traditional American jewelry is often a symbol of belonging—being pinned, being sworn in, being committed, or being loved. Pamela's jewelry might be the exact opposite—it's about expressing, empowering, and loving oneself. She is lucky to have connected with an ever-growing group of collectors who can appreciate that thought. One of the best examples might be Pamela's repeated arrowhead motif, made from an ancient process called knapping: in some Native American cultures, two arrows pointed toward each other is a sign of friendship—pointed away, it means war.

What's more, she provided an alternative to unsustainable, unethical methods of design with a focus on craftsmanship and fine materials that have been responsibly sourced. It was never about the easiest or most profitable path. Some of her pieces that are the most technically difficult to engineer and difficult to wear—like her Moroccan-inspired "5 Spike" earring—became best sellers. She set out to make jewelry that tells a story and lasts forever. Then in 2014, she applied her same methods to the fine jewelry category. She developed iterations of her signature pieces—and more—that were wrought by hand via nearly impossible-to-master techniques and with the most precious materials available.

Like her first mentor, Pamela created a world for those who collect and wear her jewelry to escape to. Where she goes and what she sees greases the wheels of her imagination and helps define her as a designer. Consider this book a ticket to the transcontinental and sometimes otherworldly trip that is her creative process. Let her muses muse you and let her manifestations manifest in you. It's like magic.

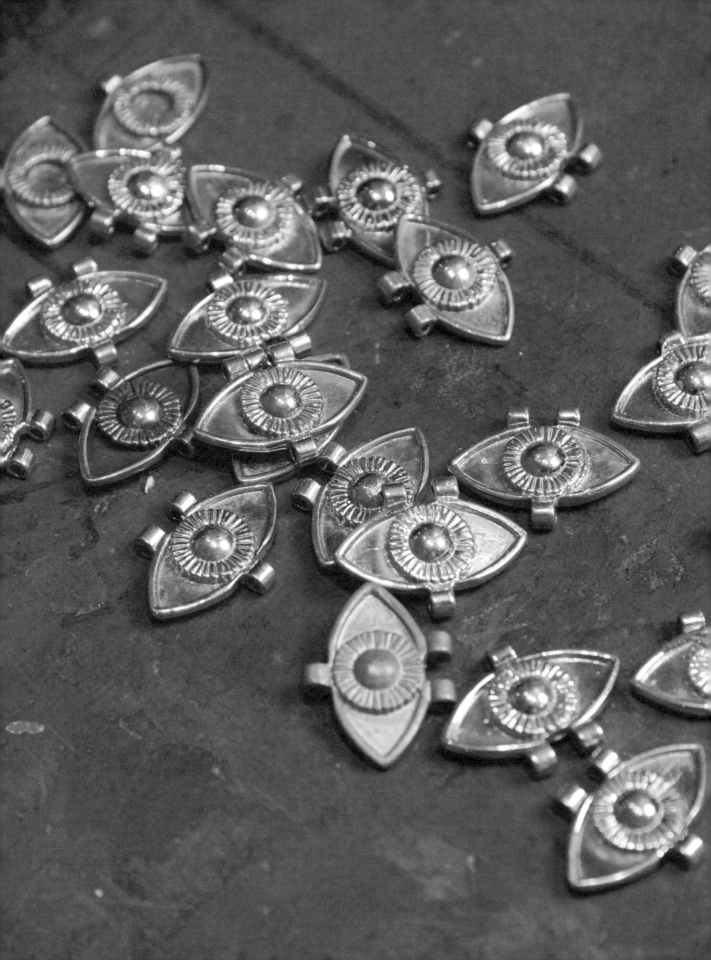

A Letter from Basra
Francesco Clemente

A letter from Basra.

I like to imagine Pamela Love sitting, in oriental costume, on the shore of a beach in medieval Basra, waiting for the pearl divers to bring her pearls.

Basra, in the Middle Ages, is where the sages of the Kabbalah and those of the Shi'a faith invented and enriched each other's cosmologies.

I like to imagine Pamela Love making amulets for the Sufis and for the Kabbalist saints, choosing shapes from both traditions, mingling their cosmological diagrams: concentric circles and squares, intersecting triangles—the geometry of the stars, which is also the geometry of the spirit and, more importantly, the geometry of the heart.

In the Middle Ages the name Basra meant "the place where many paths meet." Today's world is, more than ever before, "the place where many paths meet." Pamela Love has chosen, with her jewelry, to embrace this renewed synchronicity of cultural signs.

The Native American chief, the New Age witch, the rock star, the Mexican silversmith of old, the paleontologist manically collecting fossils, the Catholic nun clinging to her beloved ex-voto, the gothic sex goddess—they could all have recognized and adopted one element or another of Pamela Love's language.

And Pamela Love's language is bold. She never chases her audience with the easy seduction of neutrality. She is incapable of being bland. She is incapable of making indifferent things that no one could dislike.

In other words, she, without pretensions or claims, goes quietly against the grain of our time. She shows it is not true that only nothings—no things, meaningless things—sell well: you can be who you are, without apologies, and put your unique nature on the line and thrive.

Pamela Love's jewels are not sentimental, decorative illustrations, complements of a pleasant and mindless daily life. They continue, in innovative ways, the age-old tradition of talismans. They are objects charged with sacrality, whose aim is to connect the wearer with the Sacred, which is nothing less than the bigger picture of life.

In Pamela Love's jewelry, space travel intersects with time travel through the selection of stones and shapes.

Lapis from Afghanistan mountaintops meets turquoise from the American Southwest. Light and darkness are reconciled through the use of onyx and quartz, mystical substances since prehistoric times. Malachite, the green in the paintings of antiquity, befriends jasper, the favorite stone of the ancient world. The translucence of moonstone, once believed to originate from the petrified rays of the moon, accompanies the translucence of obsidian, the material of the earliest mirror of mankind, 5,000 years BC and beyond.

The shapes, too, resonate one into the other, connecting what is above to what is below.

Spikes remind one of South Indian temple jewelry. Eyes conjure Middle Eastern charms. Swords bring in the iconography of Catholic martyrs. Infinity signs disrupt the phases of the moon. A starry sky is reflected in an arrowhead.

What is larger than us, its coldness and maybe our terror of it, descends from above and finds a nest—cozy, warm, and personal—around the wrist or the finger or the neck of a girl we know, and we can look at it safely and up close. We can be happy, dreaming of a life whole and without fear.

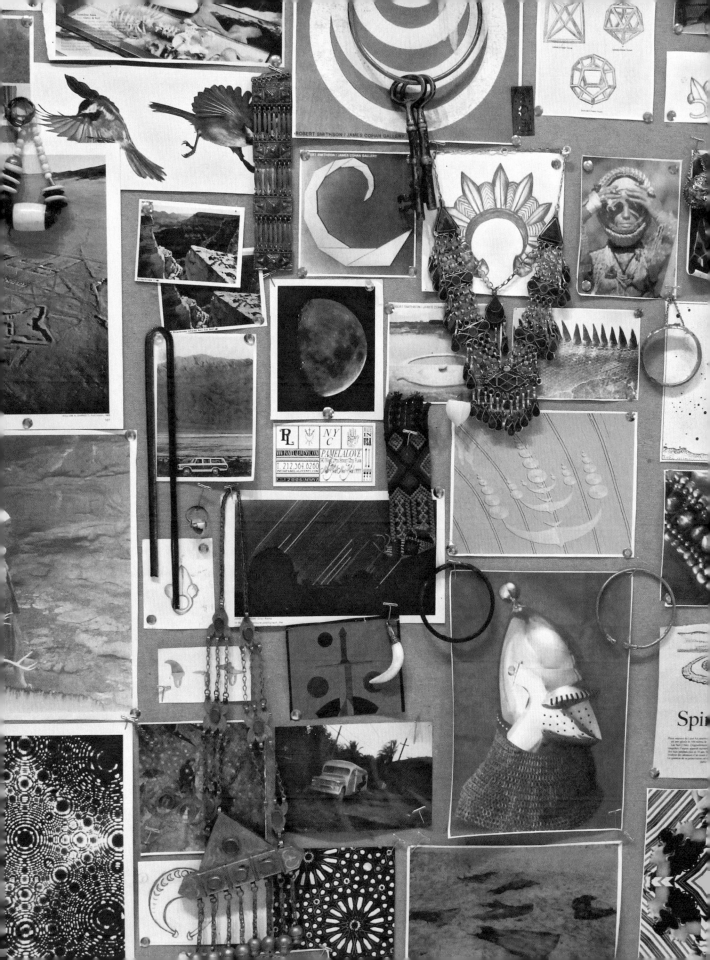

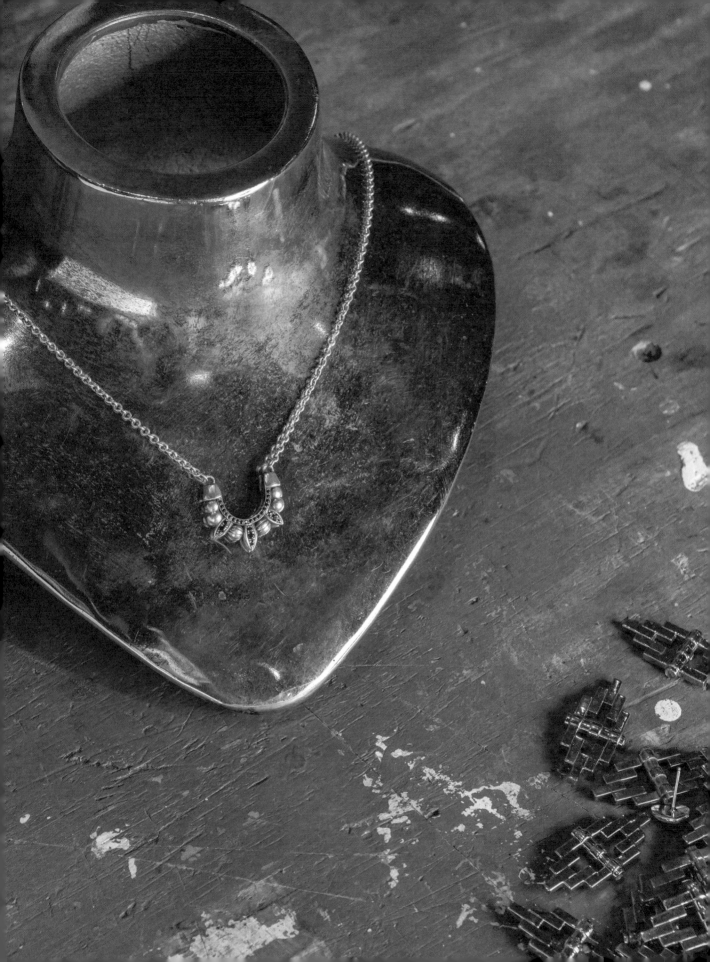

New Years Resolutions

1 Paint! as much as Possible

2. Play drums as much as Possible

3. Get Jewelry business Going!

10. Better eating Habbits.

11. Get Rid of all The Jerks

19

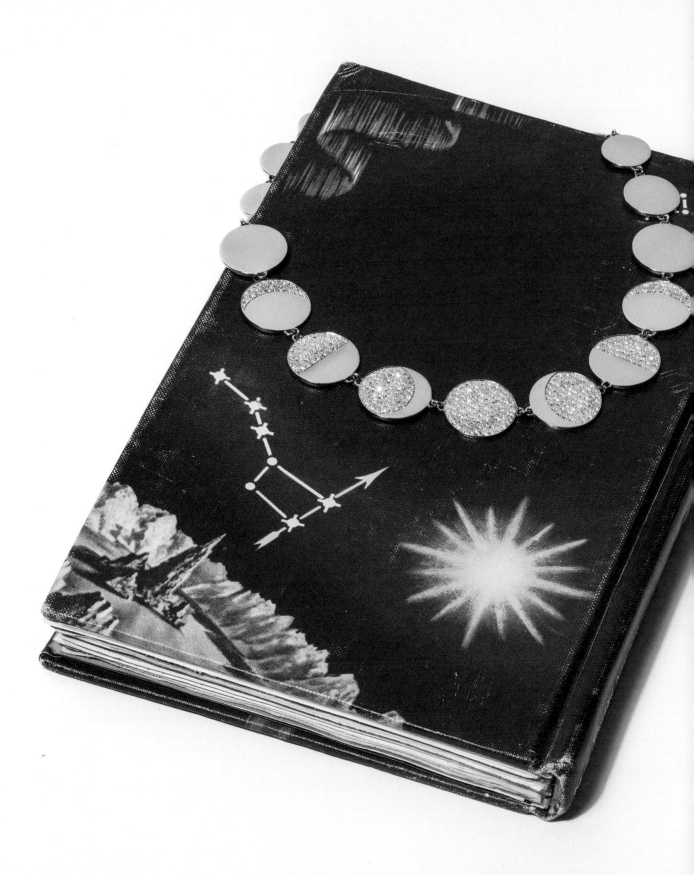

Be humble for you are made of earth.
Be noble for you are made of stars.

—Serbian proverb

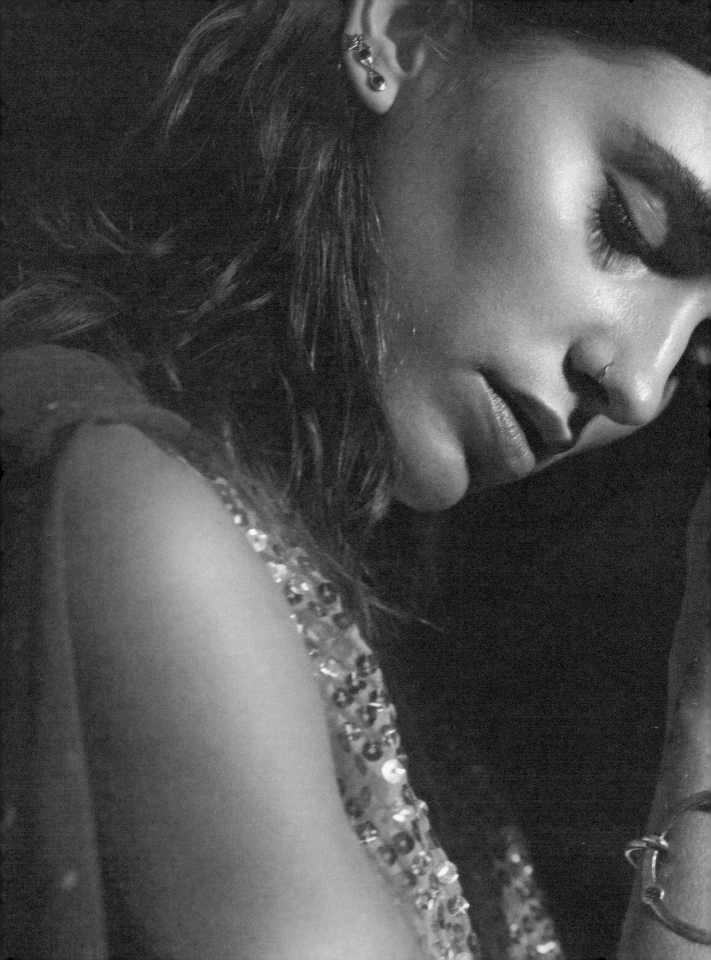

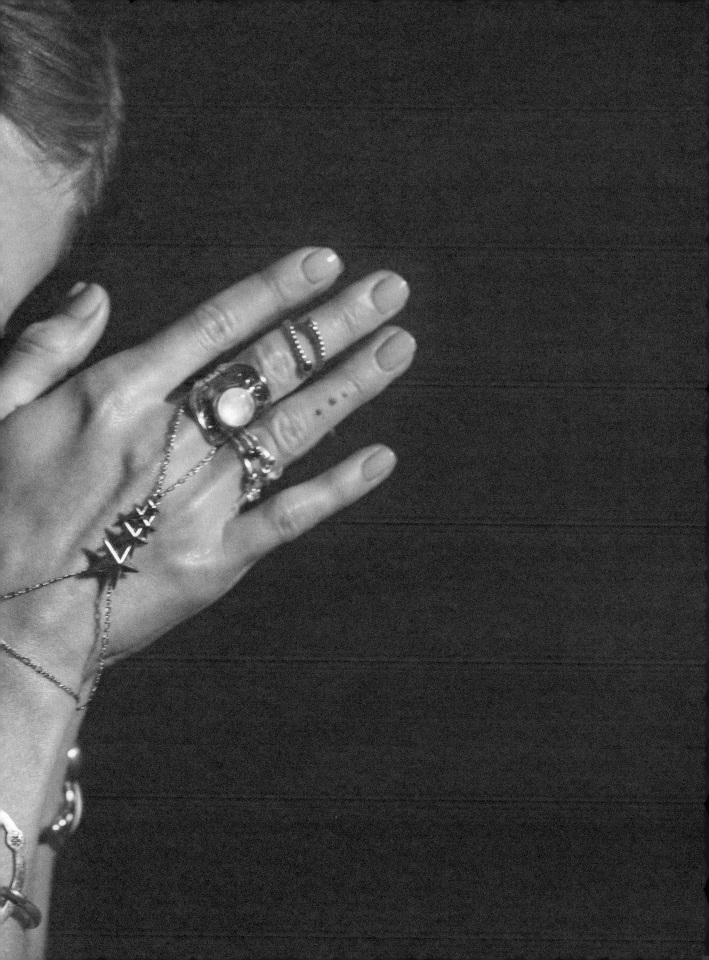

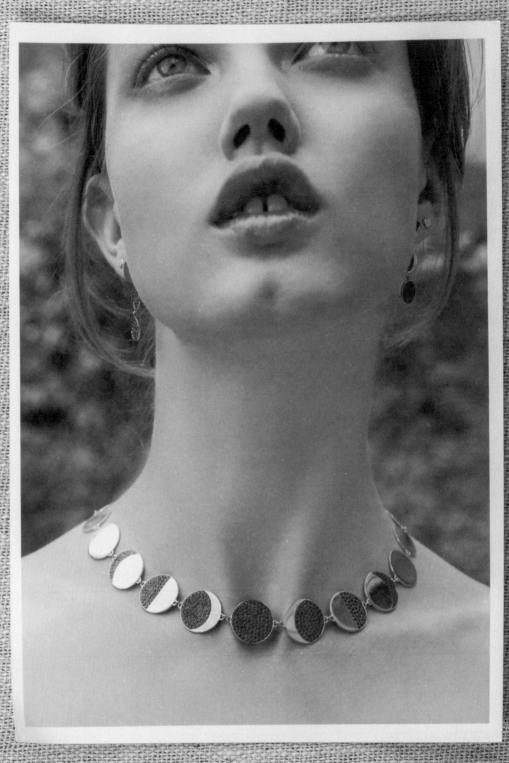

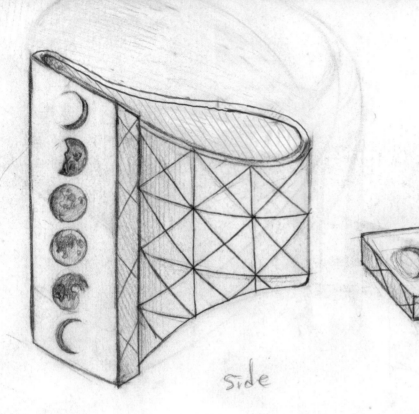

side

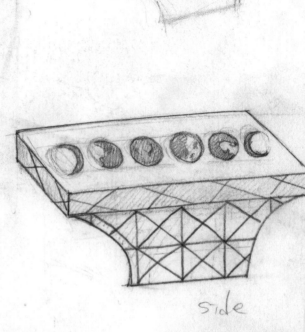

side

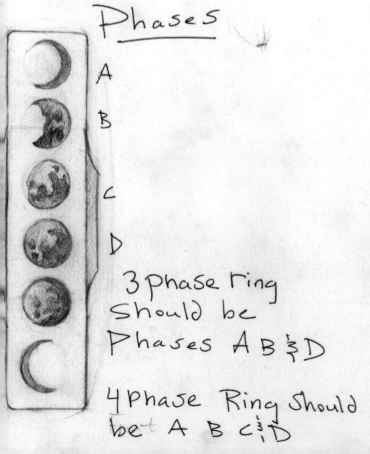

Phases

A

B

C

D

3 phase ring
Should be
Phases A B ⅓ D

4 phase Ring Should
be A B C ⅓ D

back

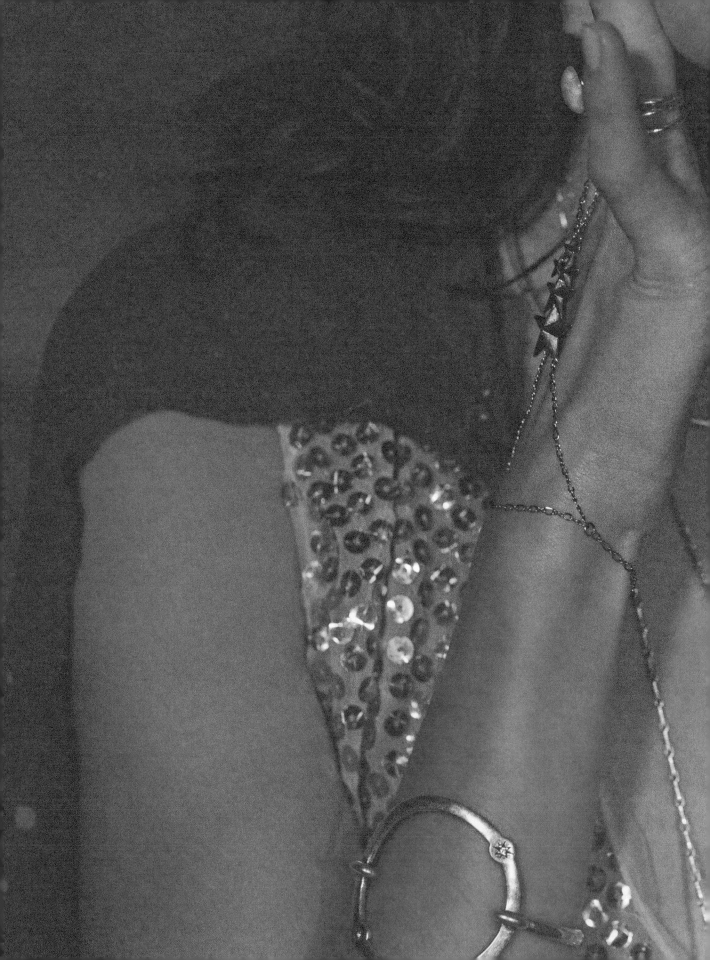

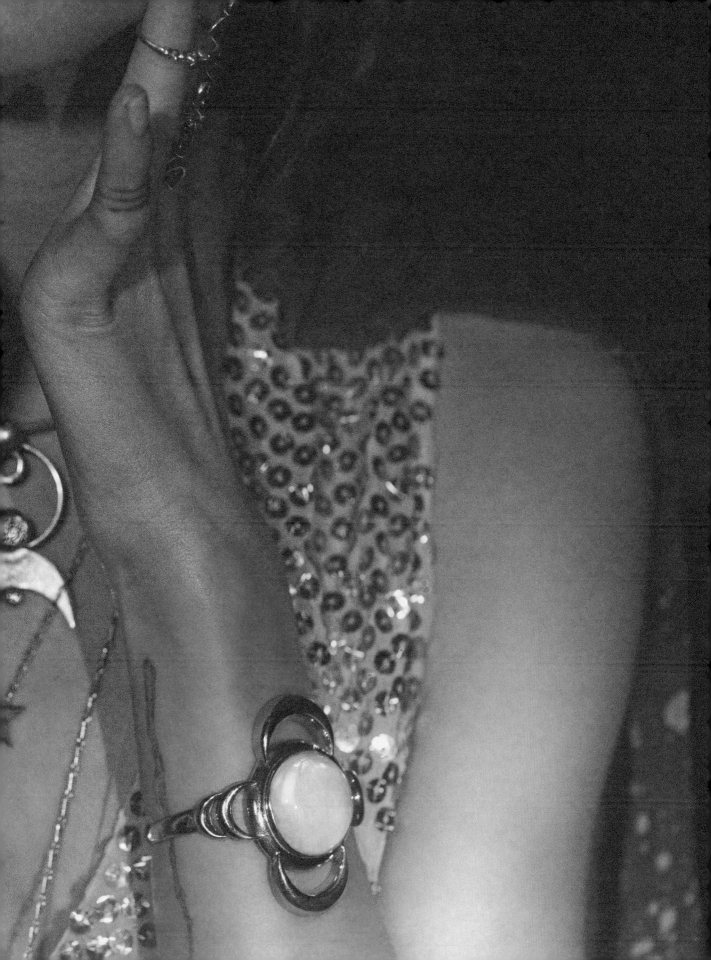

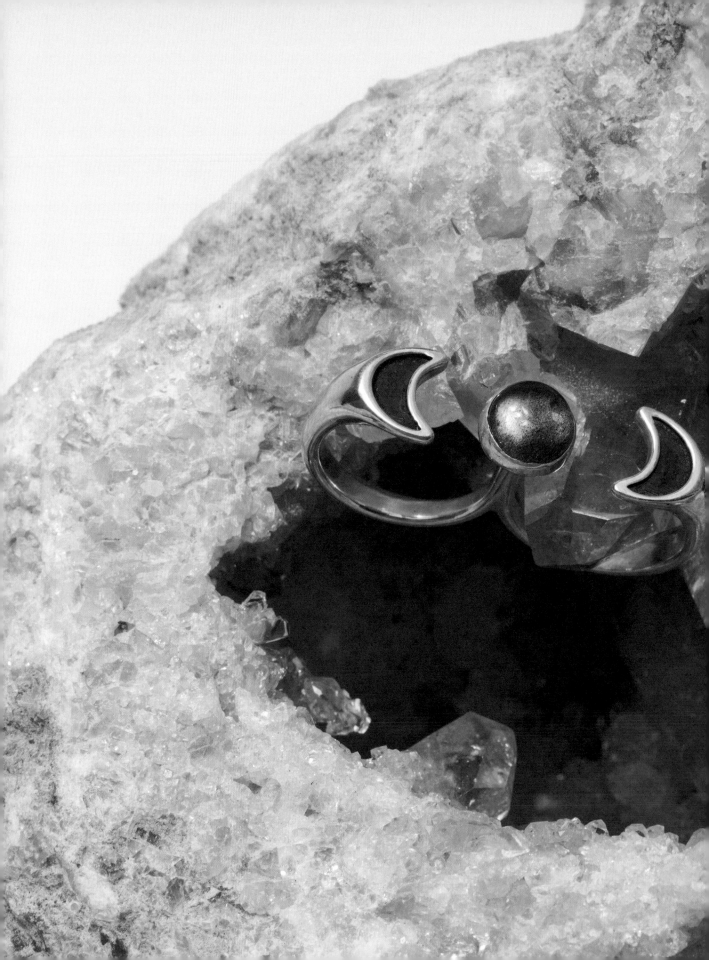

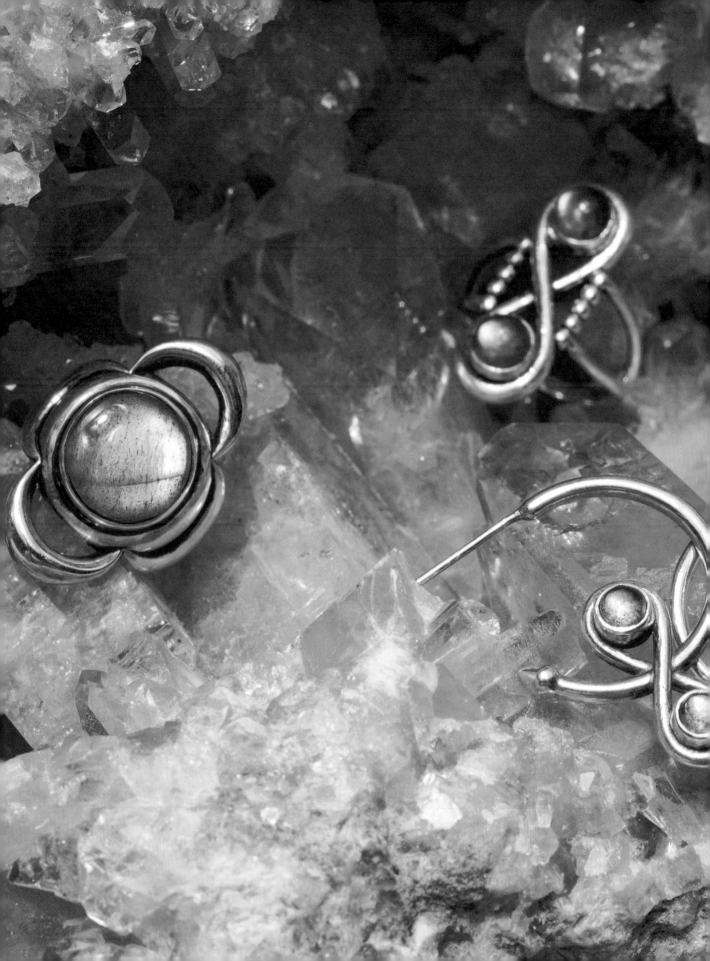

Overhead

CANES
VENATICI

LEO MINOR

COMA
BERENICES

LEO

Regulus

East

Ecliptic

CRATER

Spica

CORVUS

HYDRA

30

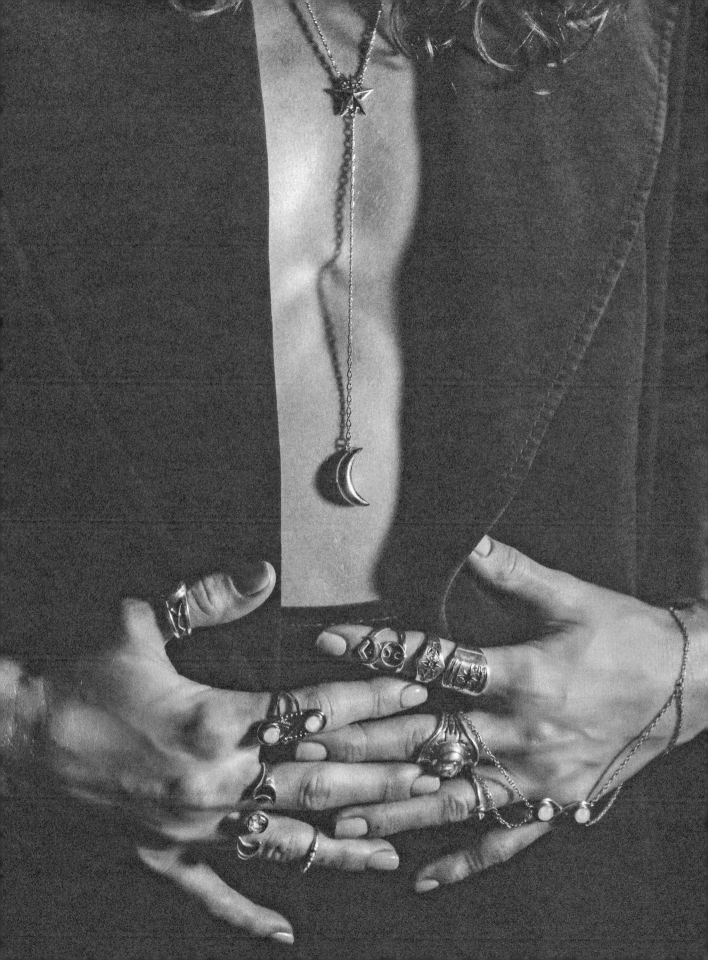

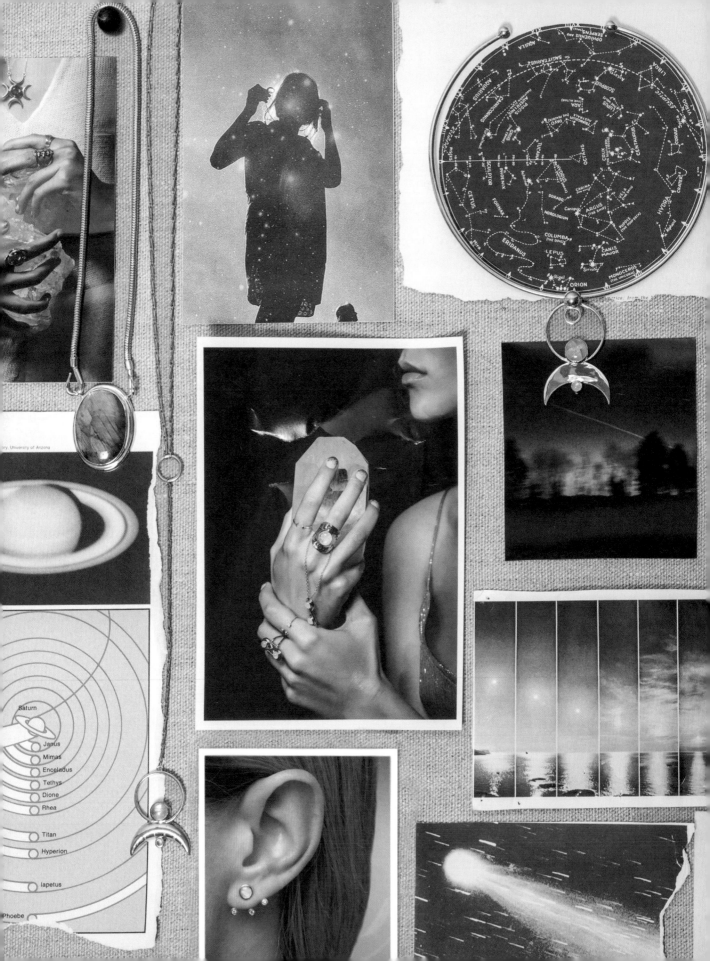

Saturn
Janus
Mimas
Enceladus
Tethys
Dione
Rhea
Titan
Hyperion
Iapetus
Phoebe

ory, University of Arizona

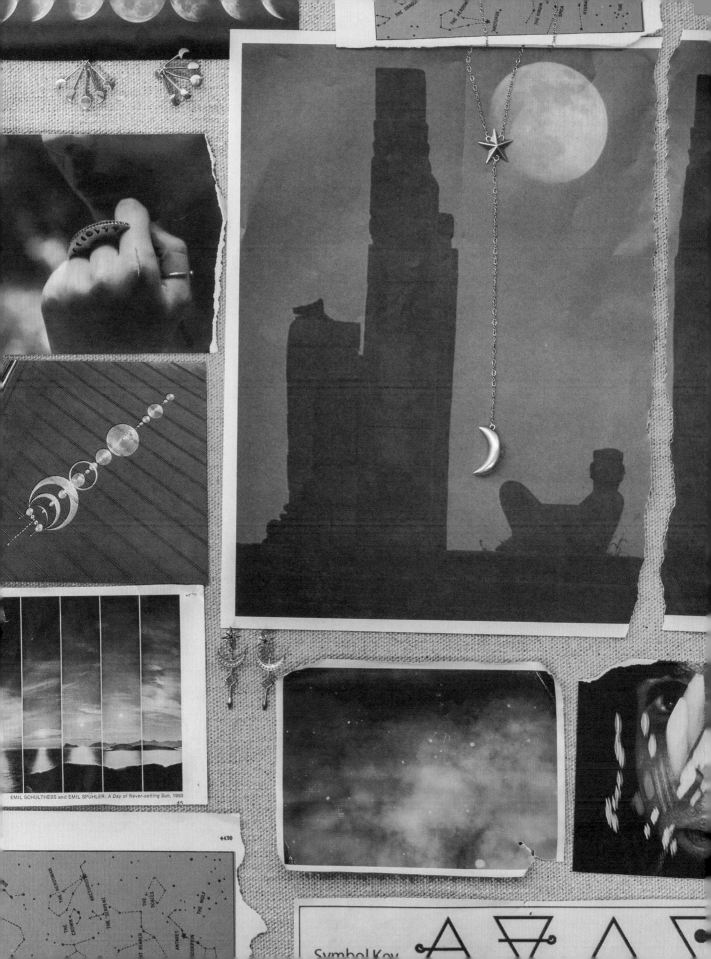

EMIL SCHULTHESS and EMIL SPÜHLER: *A Day of Never-setting Sun*, 1950
45

4430

Symbol Key

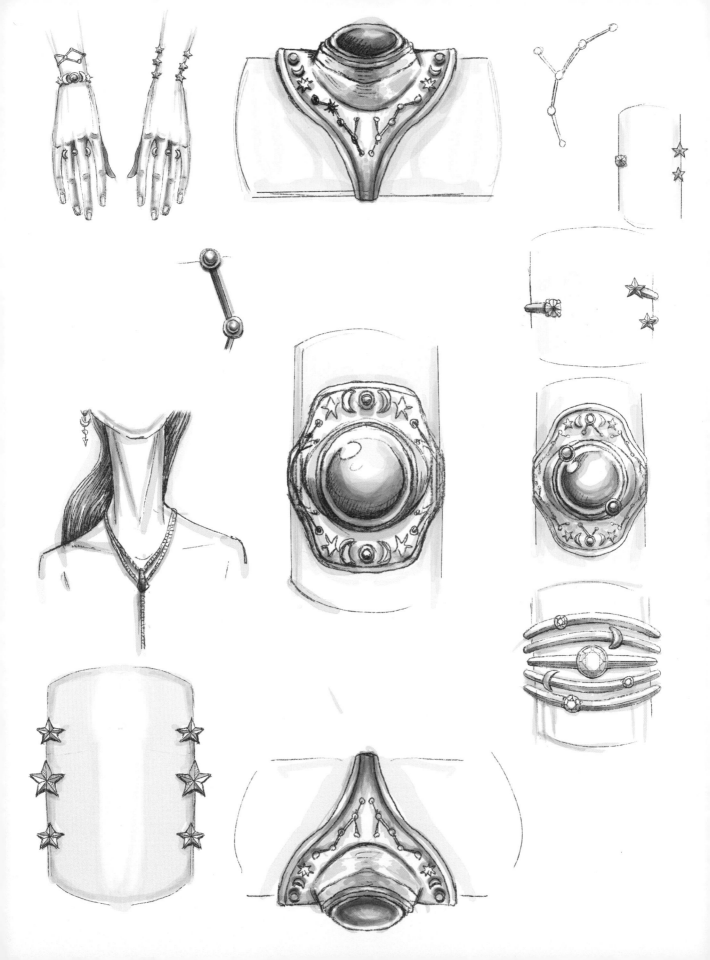

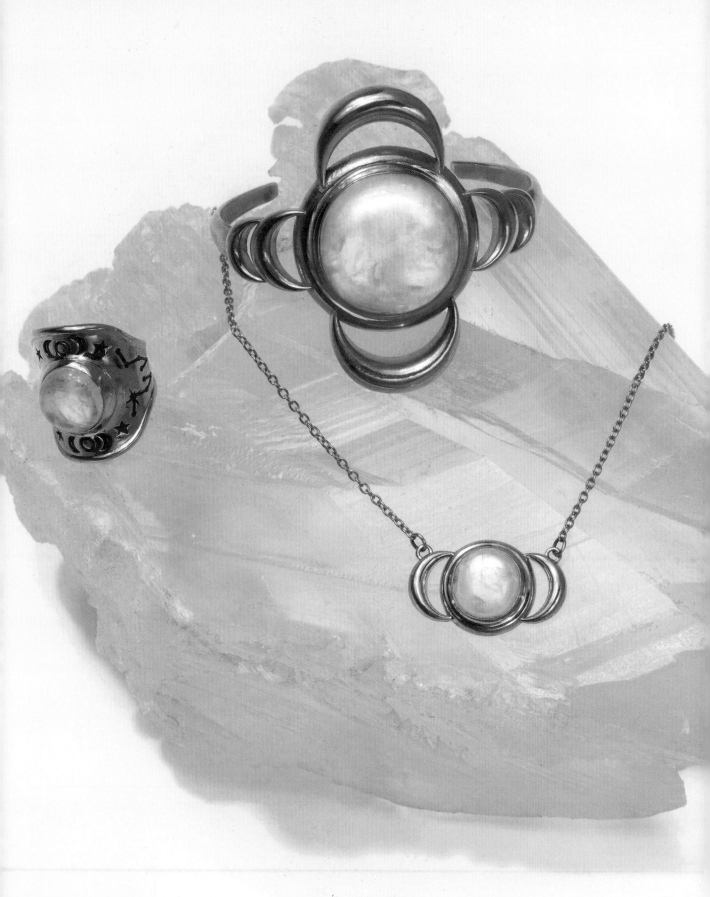

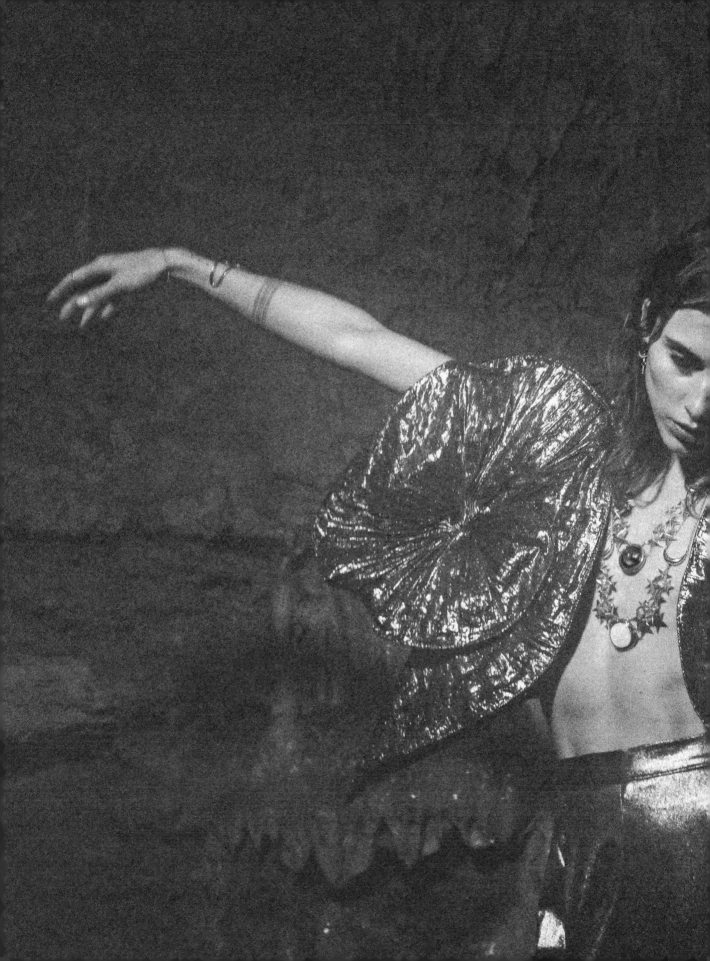

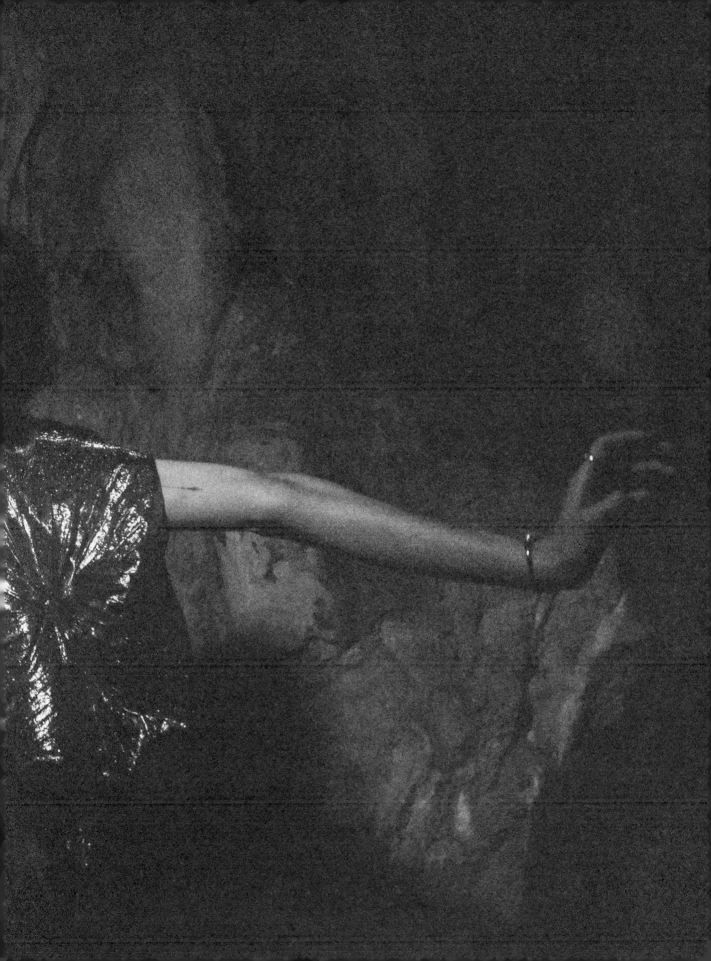

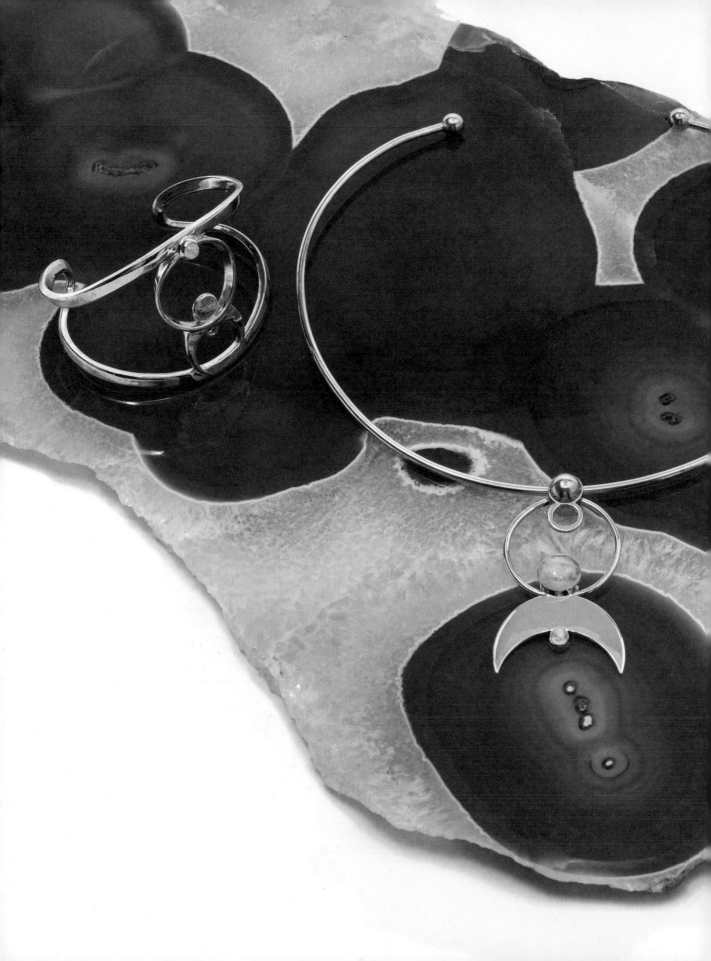

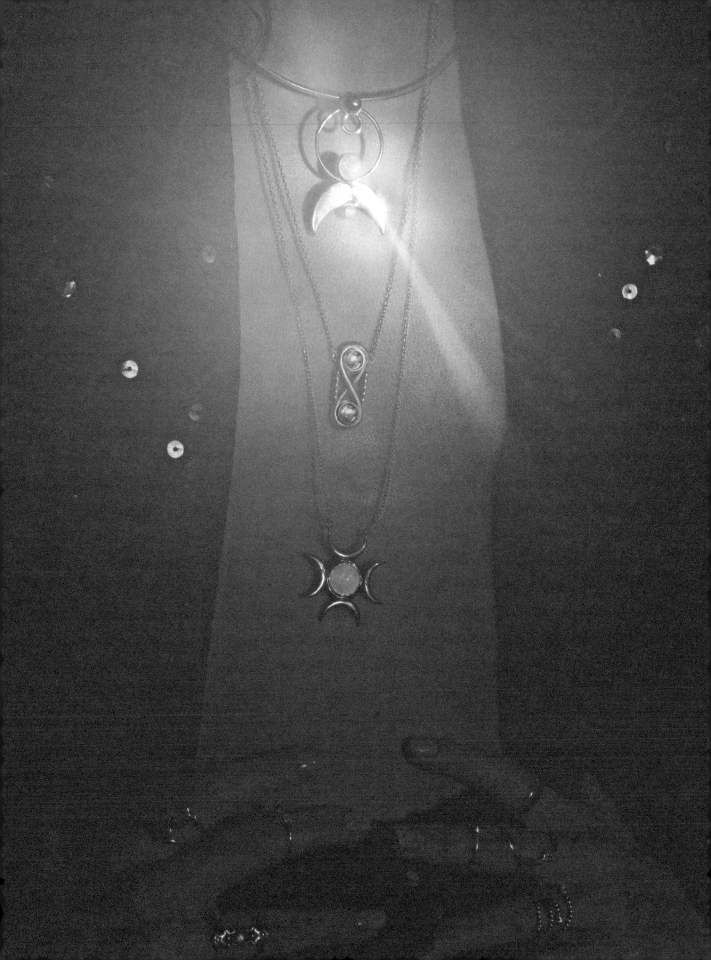

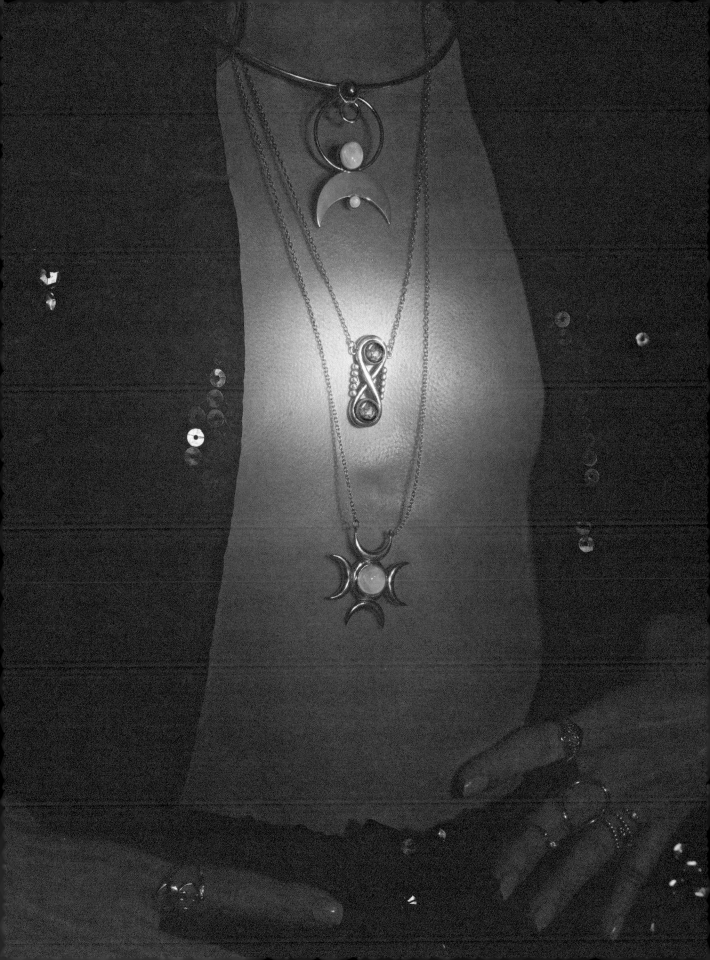

150 PAIN
STA
A GUIDE TO THE CONSTELLAT
PLANETS AND OTHER FEATUR

Francesco Clemente, *After Desnos*, watercolor on paper, 2008

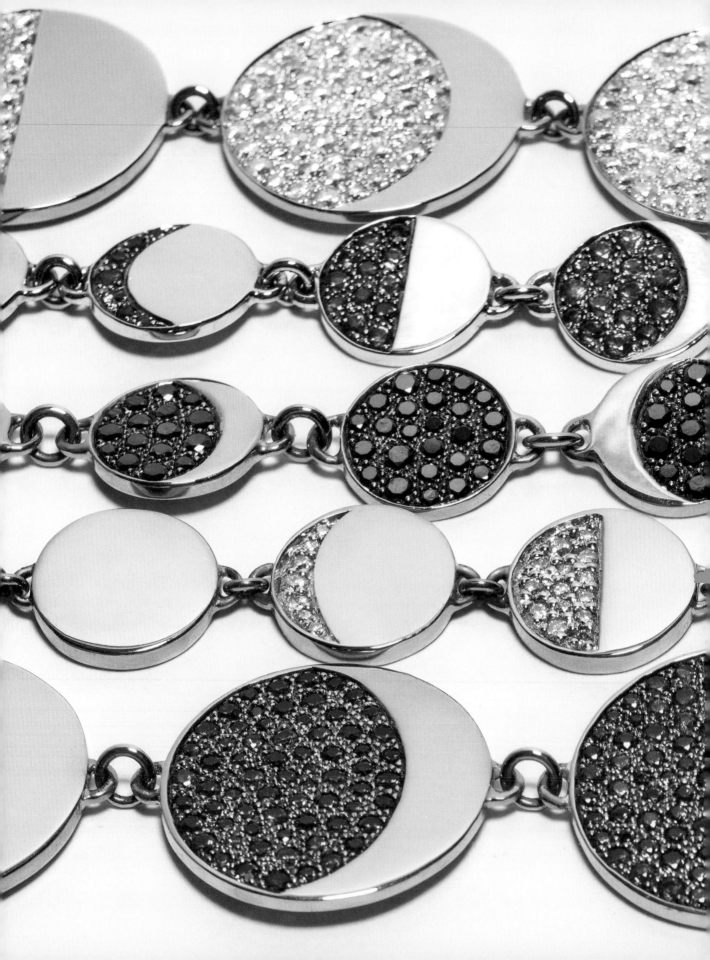

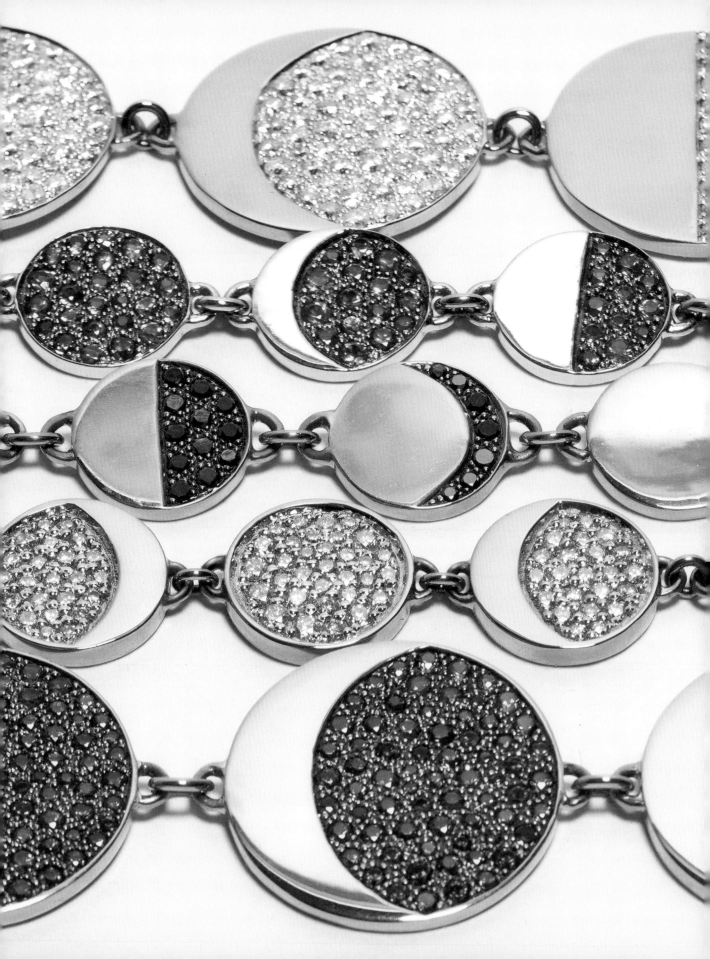

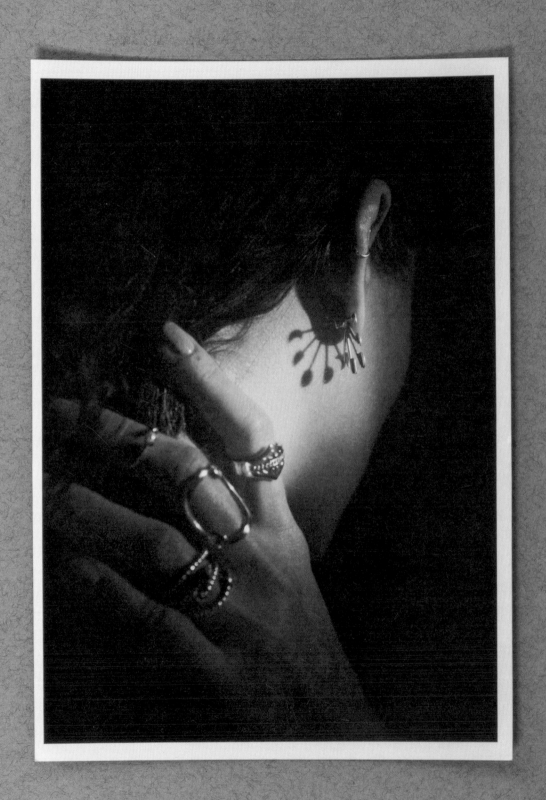

Natural Bridge Caverns, San Antonio, Texas, 2014

The whole and sole object of all
true Magical and Mystical training
is to become free from every kind
of limitation.

—Aleister Crowley

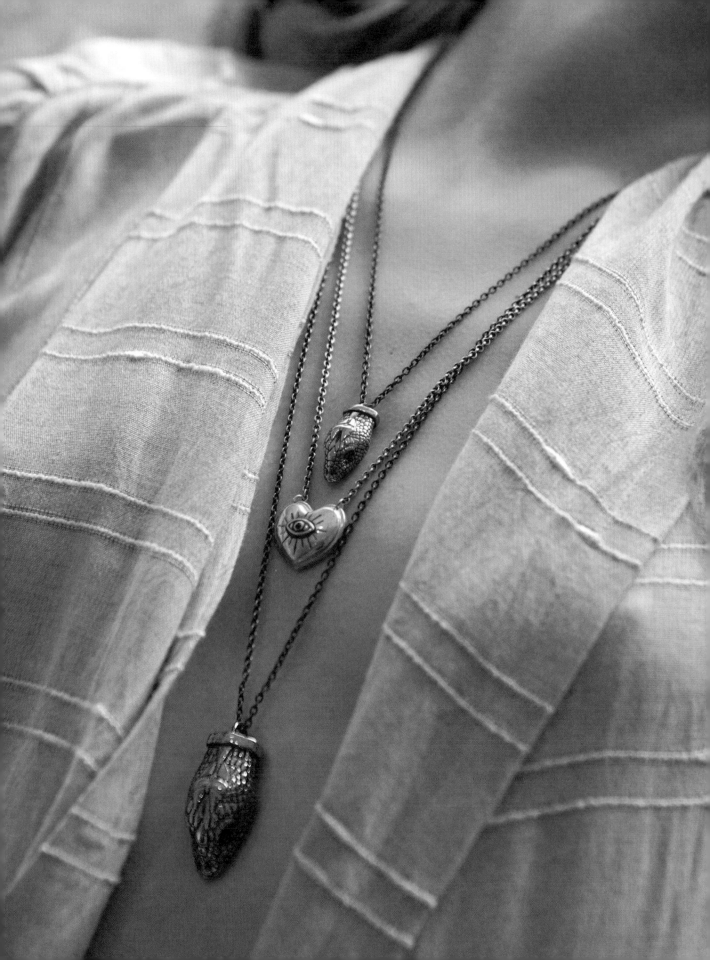

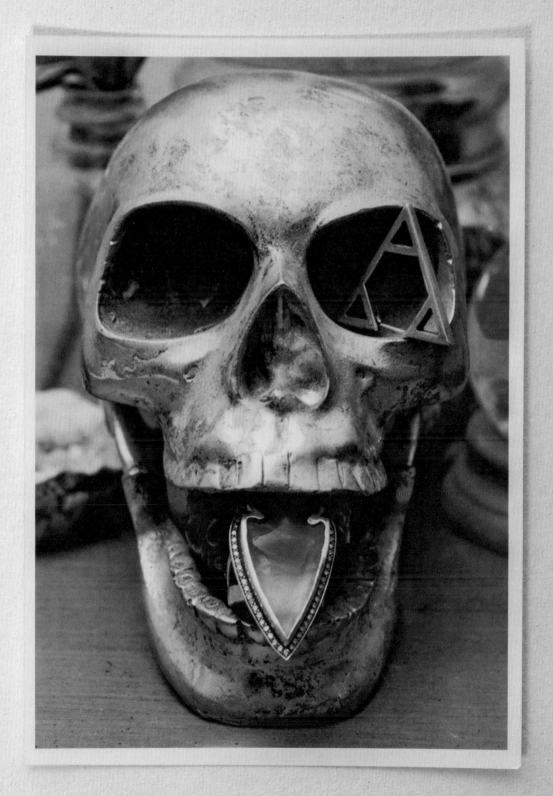

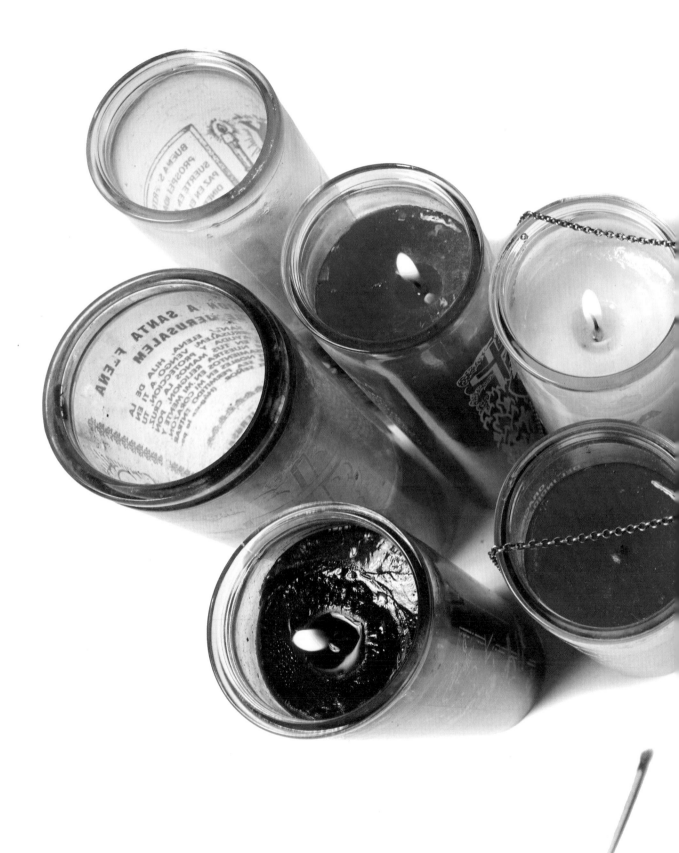

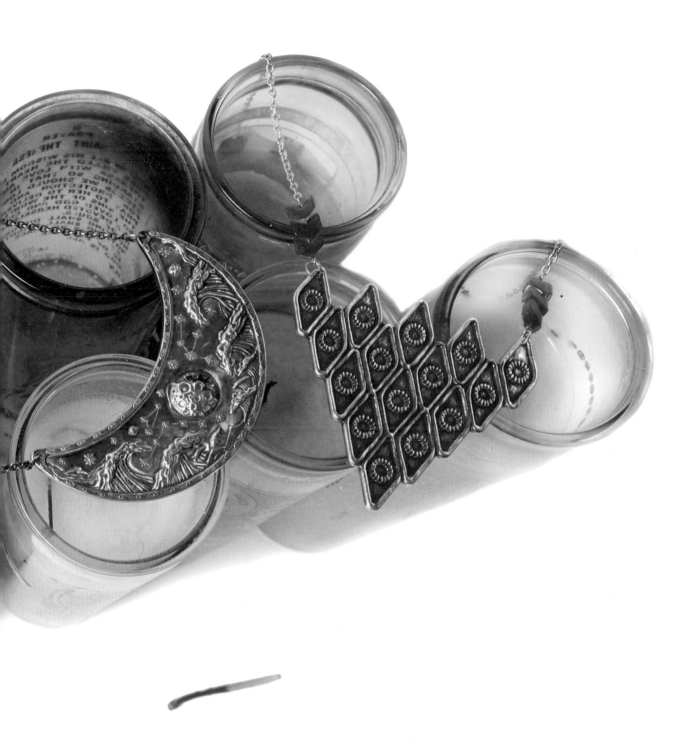

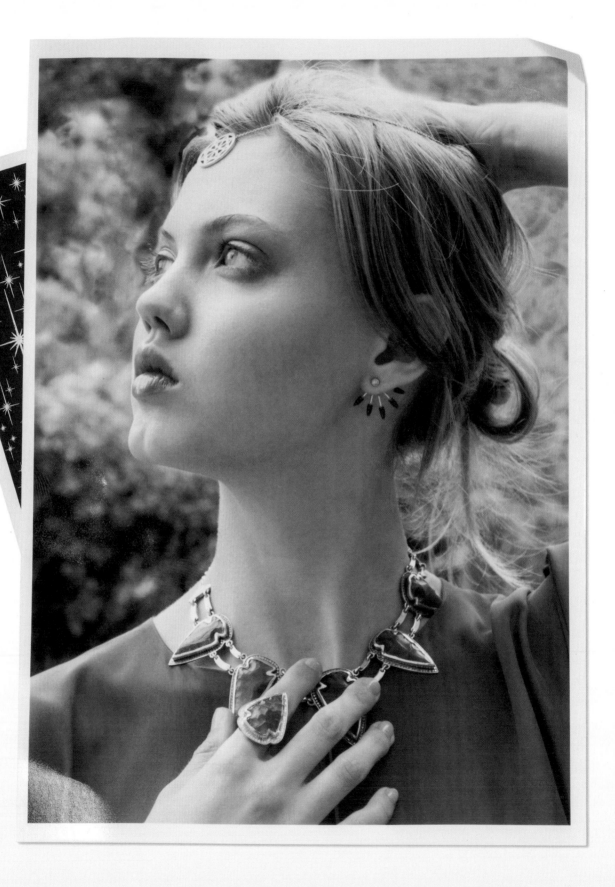

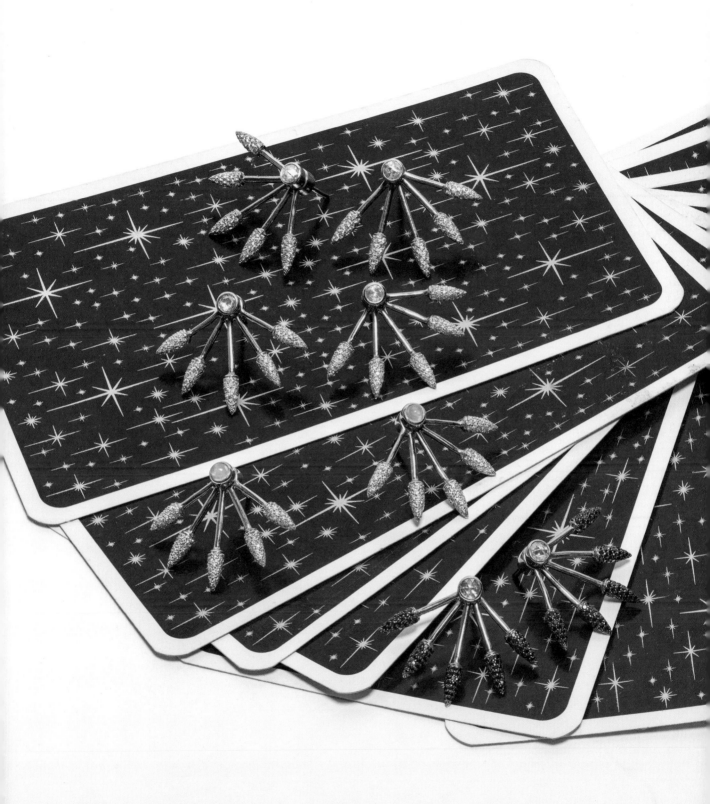

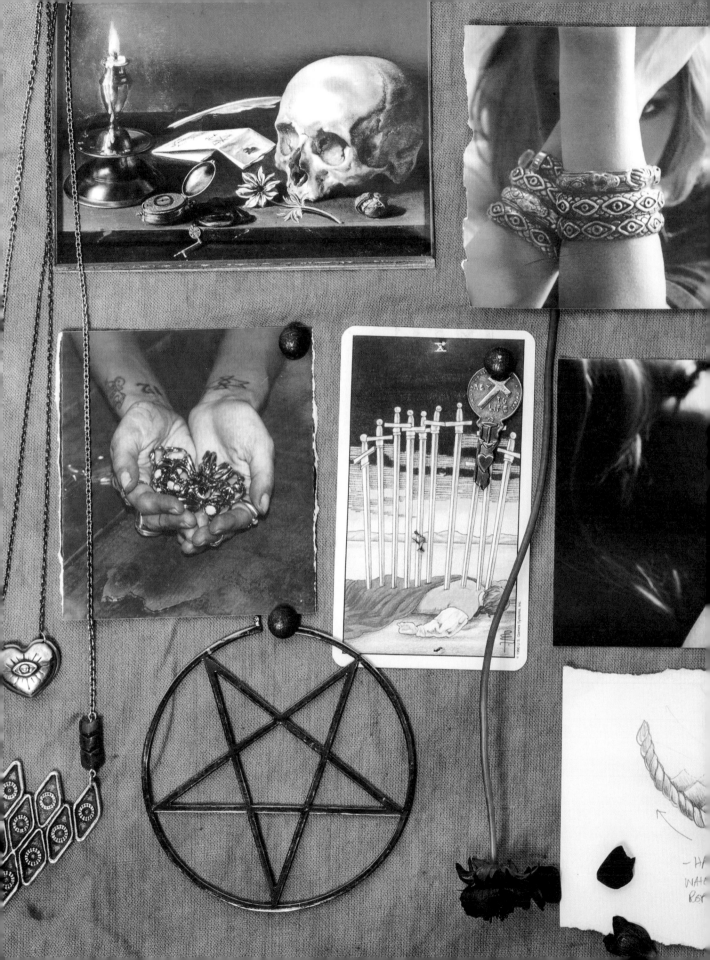

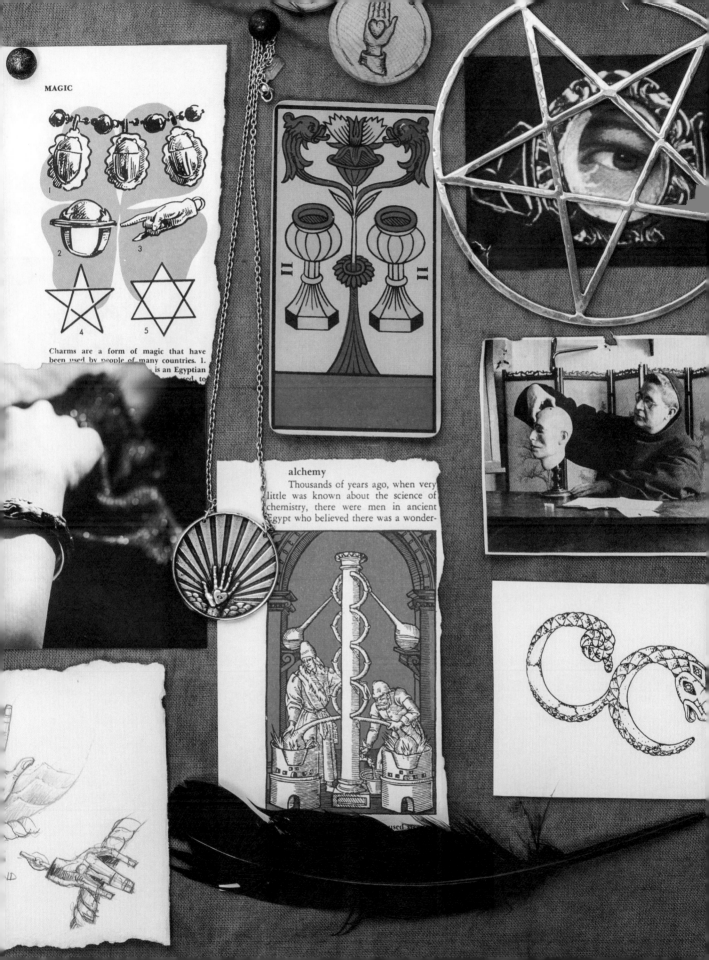

MAGIC

Charms are a form of magic that have
been used by people of many countries. 1.
is an Egyptian
used, to

alchemy

Thousands of years ago, when very
little was known about the science of
chemistry, there were men in ancient
Egypt who believed there was a wonder-

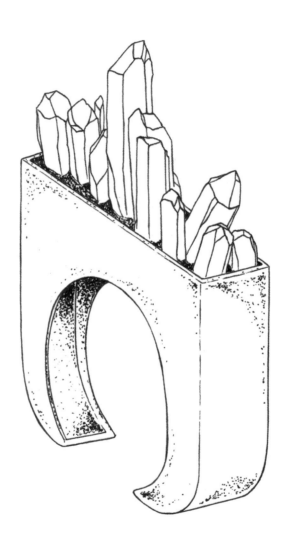

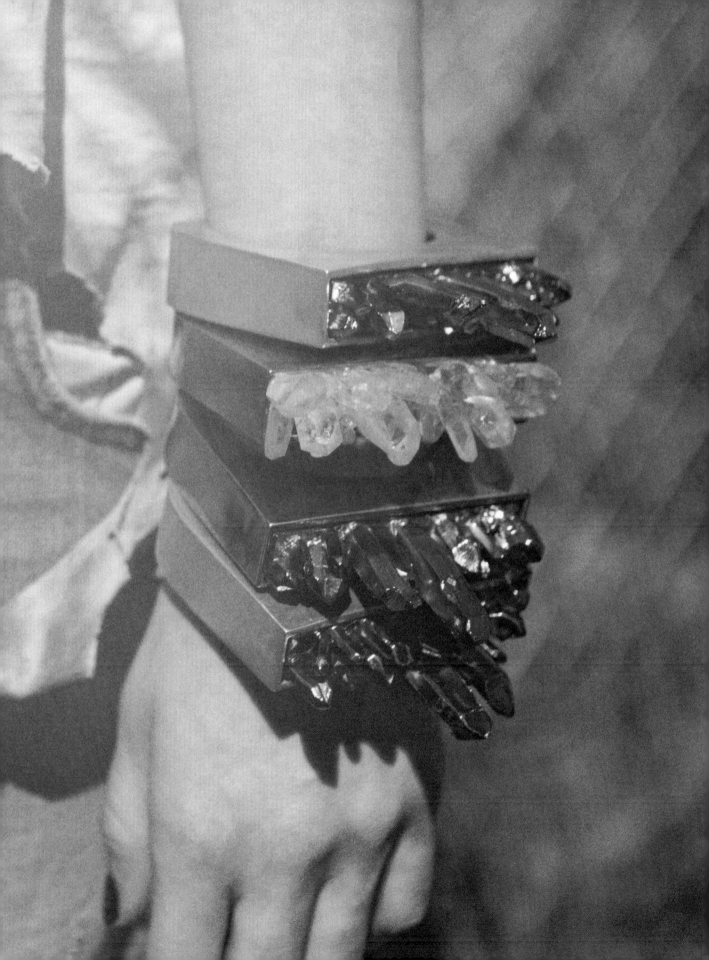

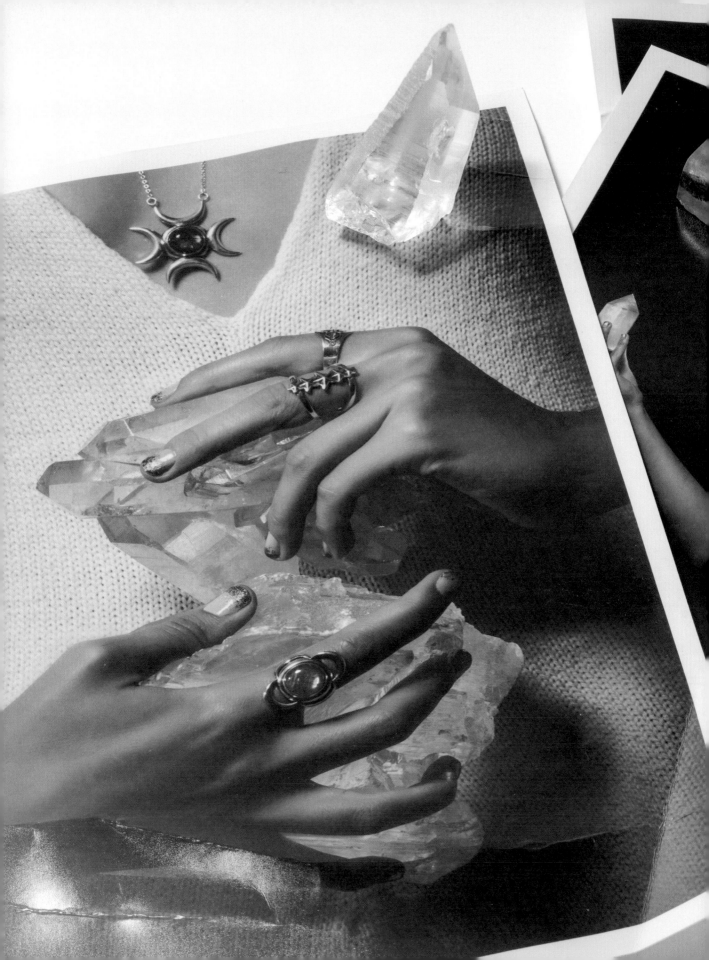

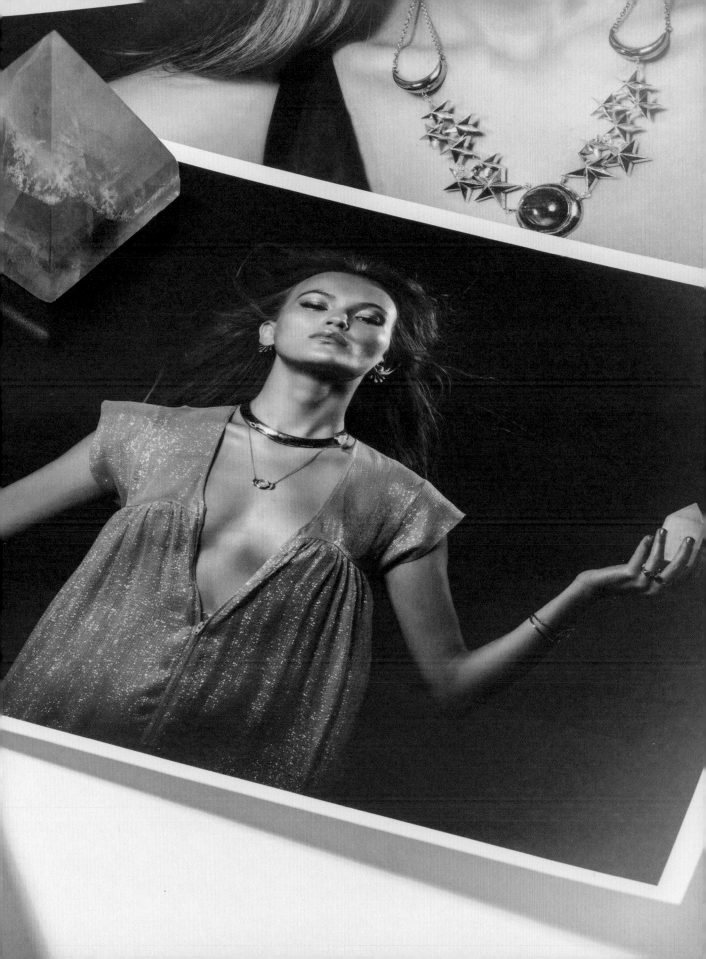

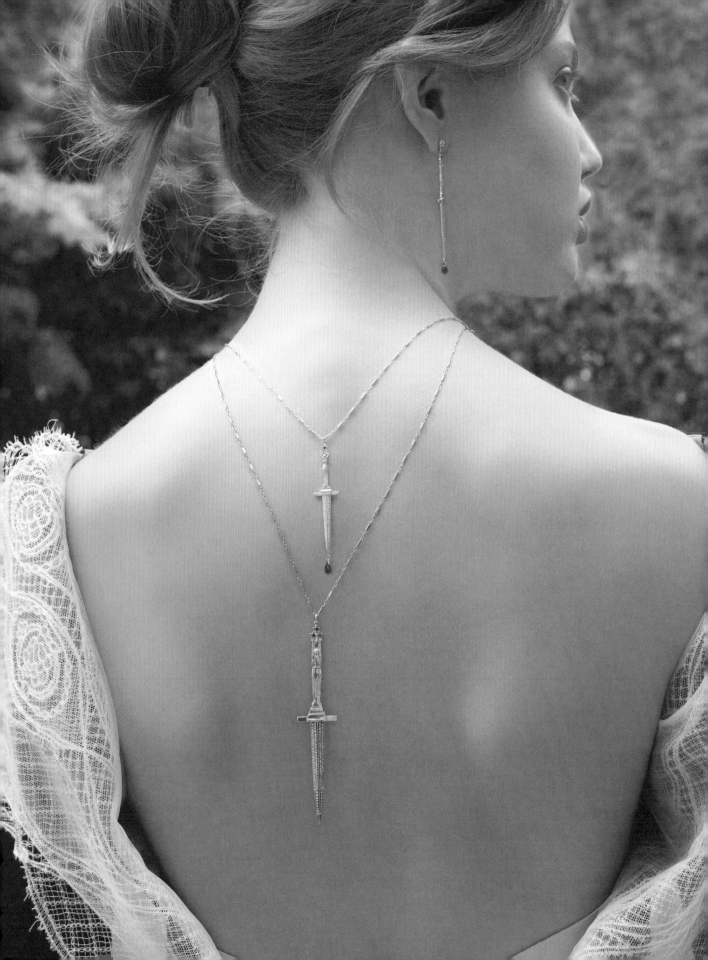

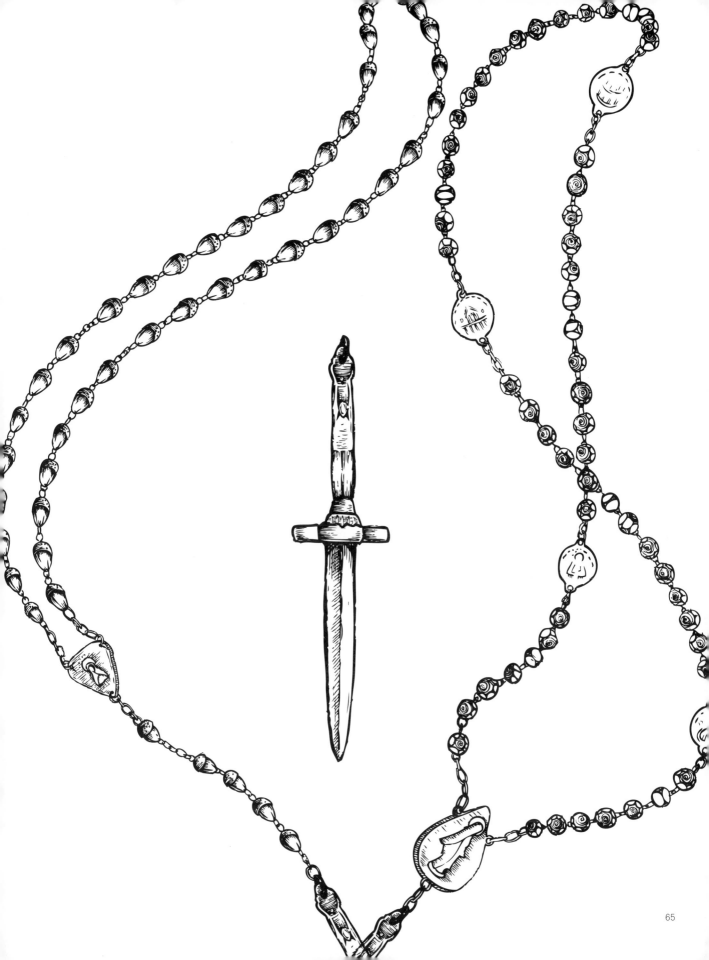

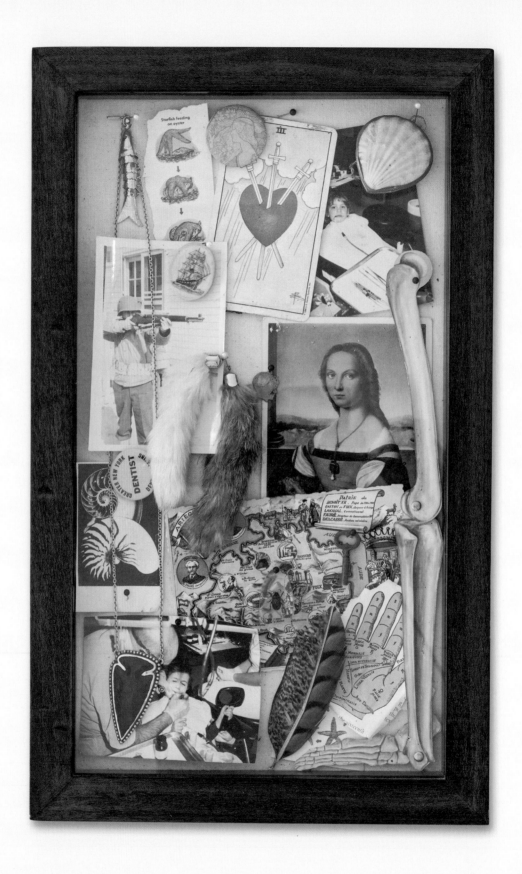

Shadow Box, 2008

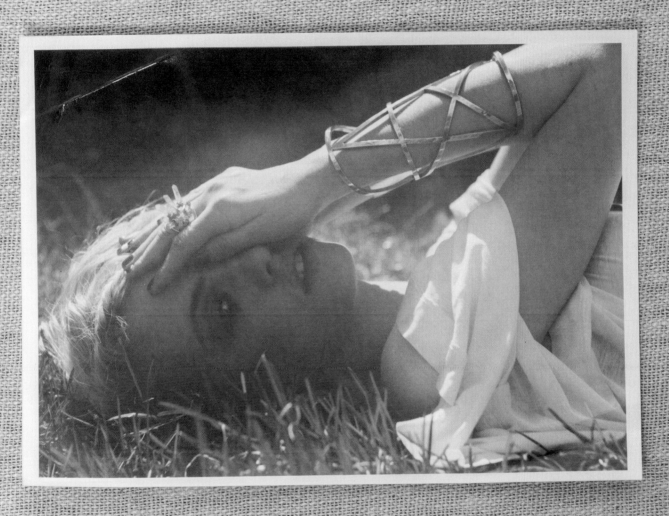

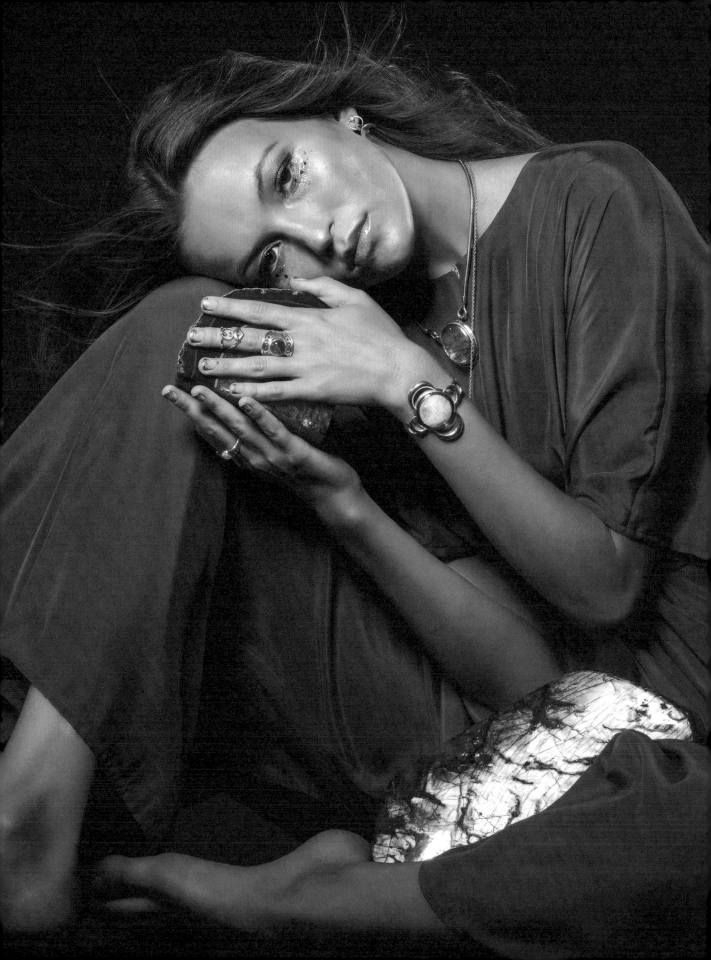

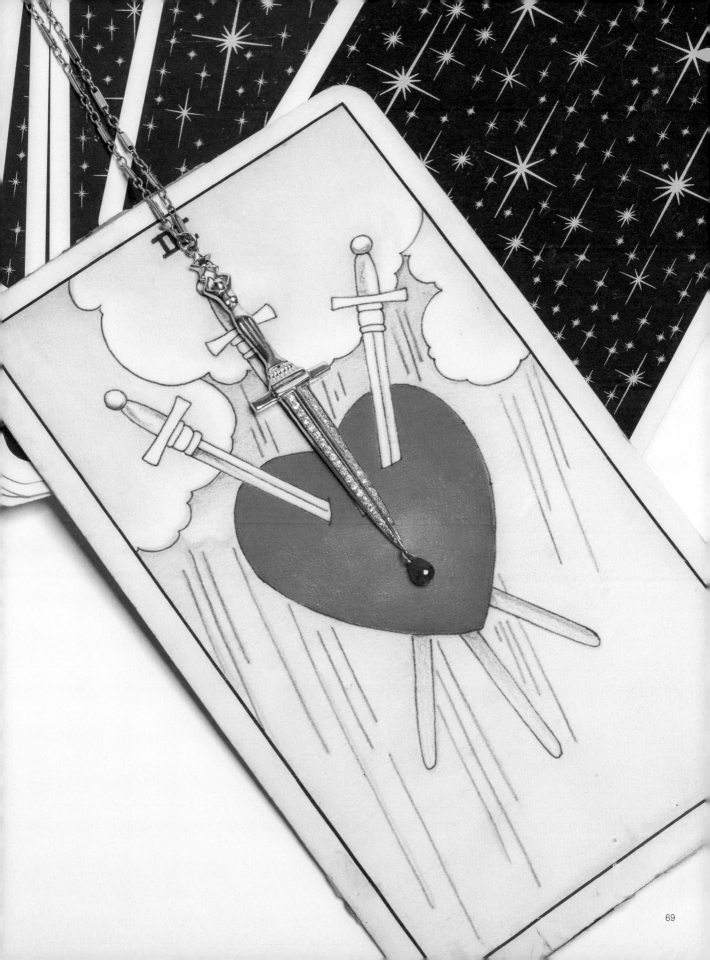

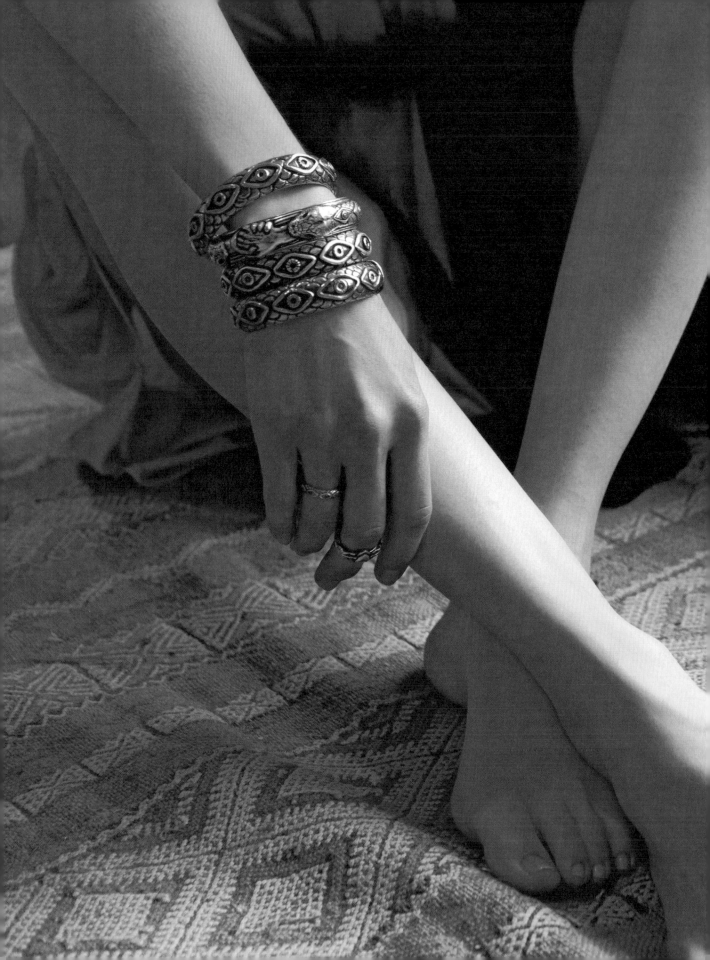

Love me or hate me,
The desert seems to say,
This is what I am,
This is what I shall remain.

—Joseph Wood Krutch

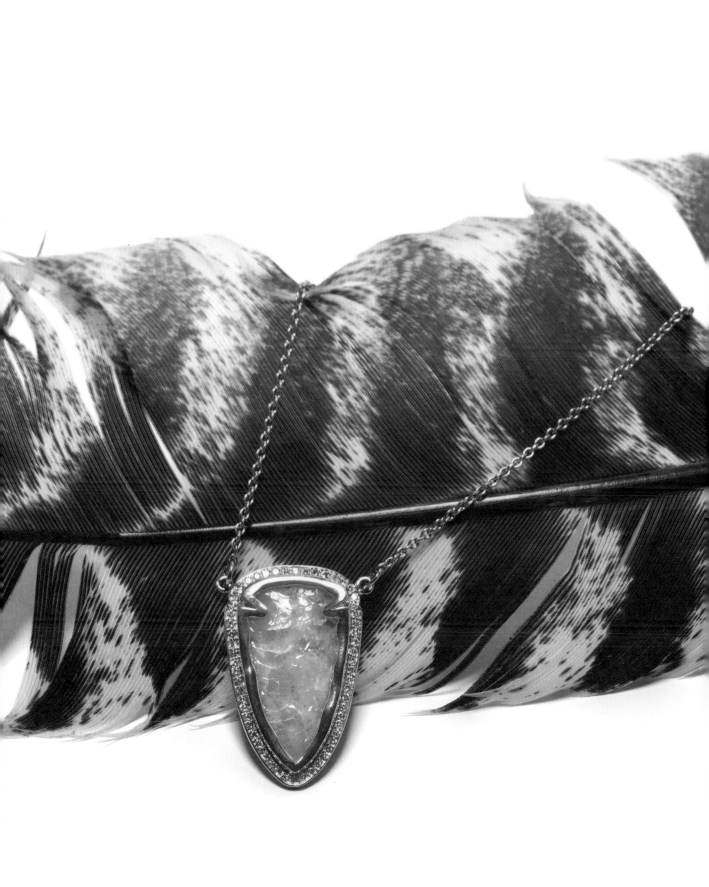

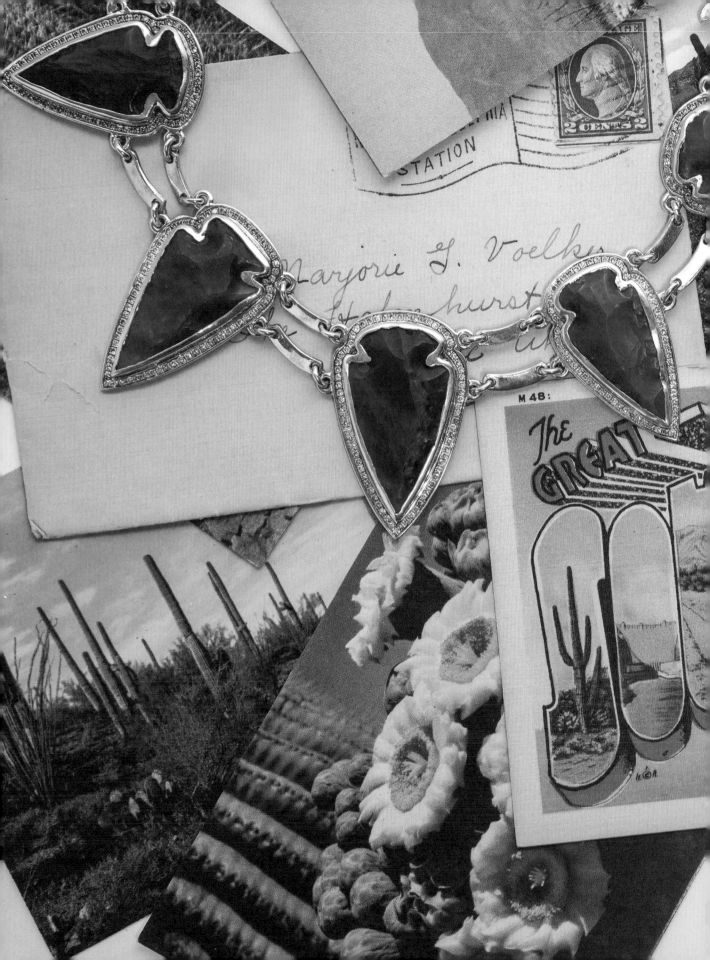

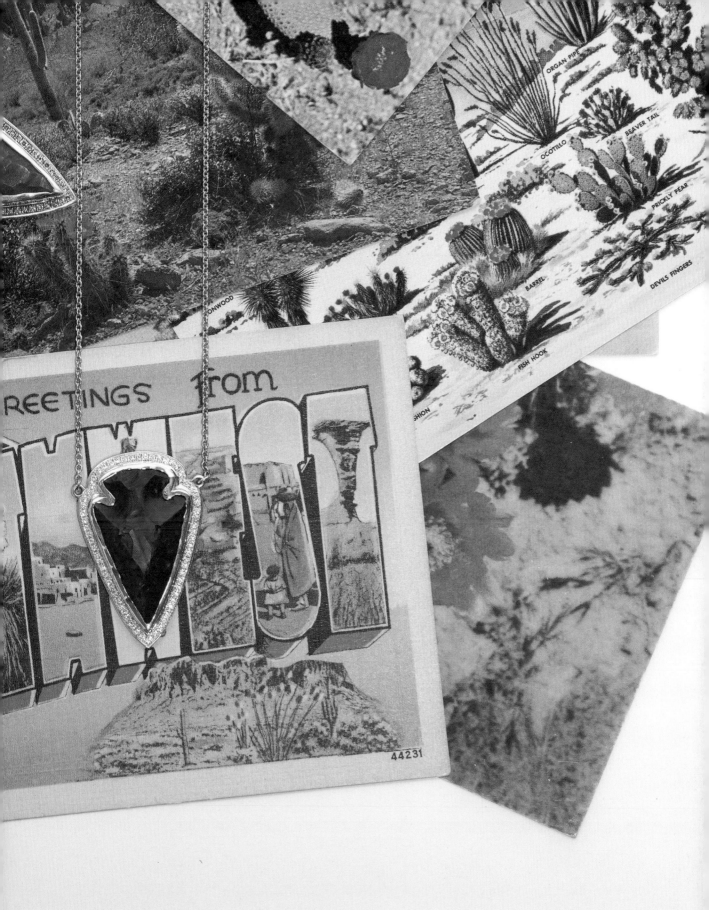

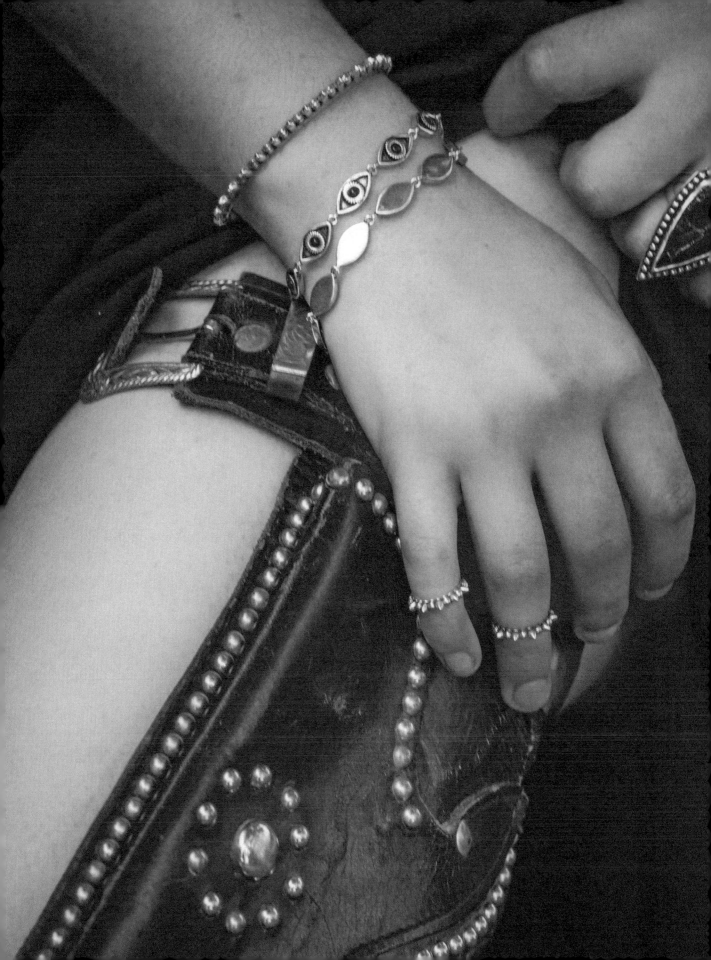

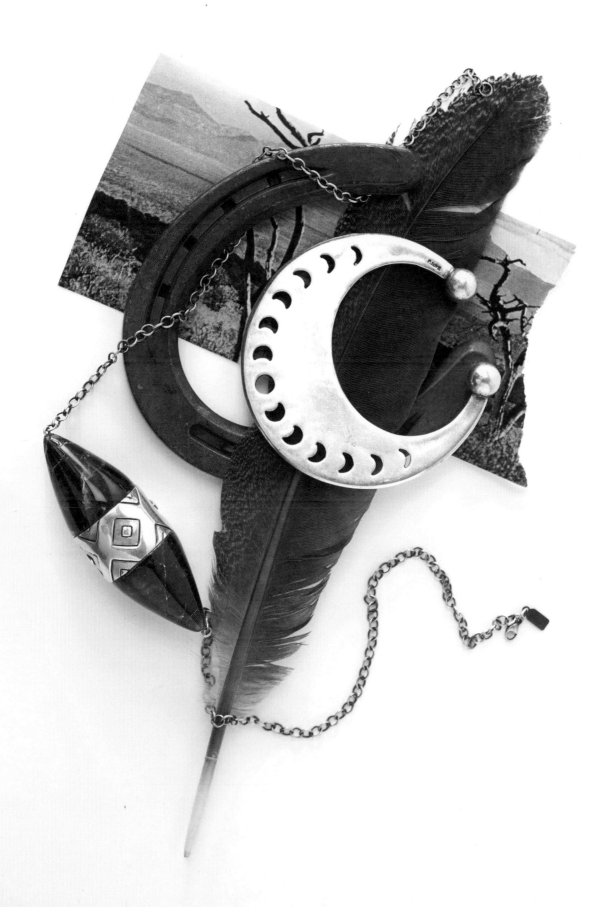

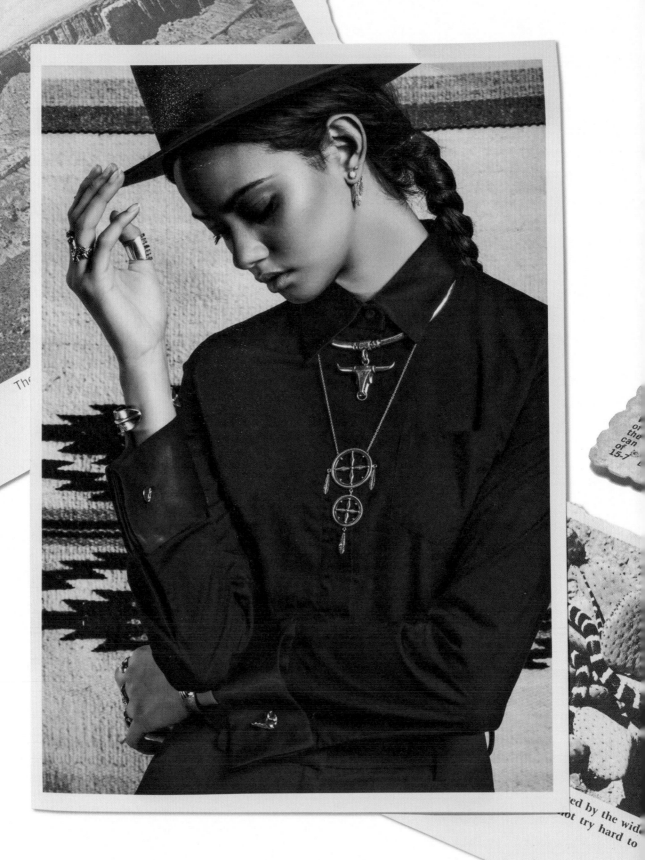

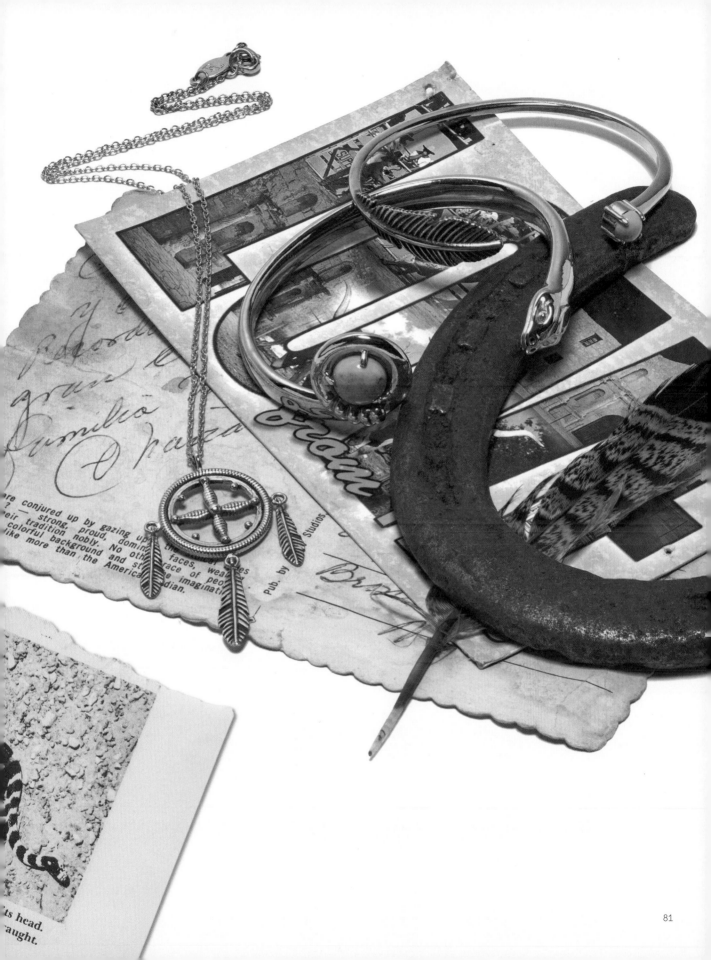

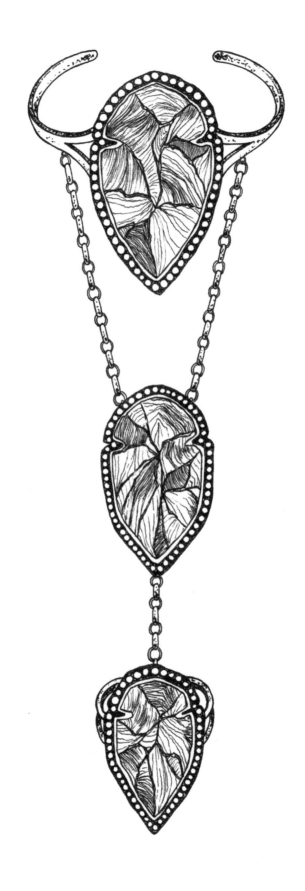

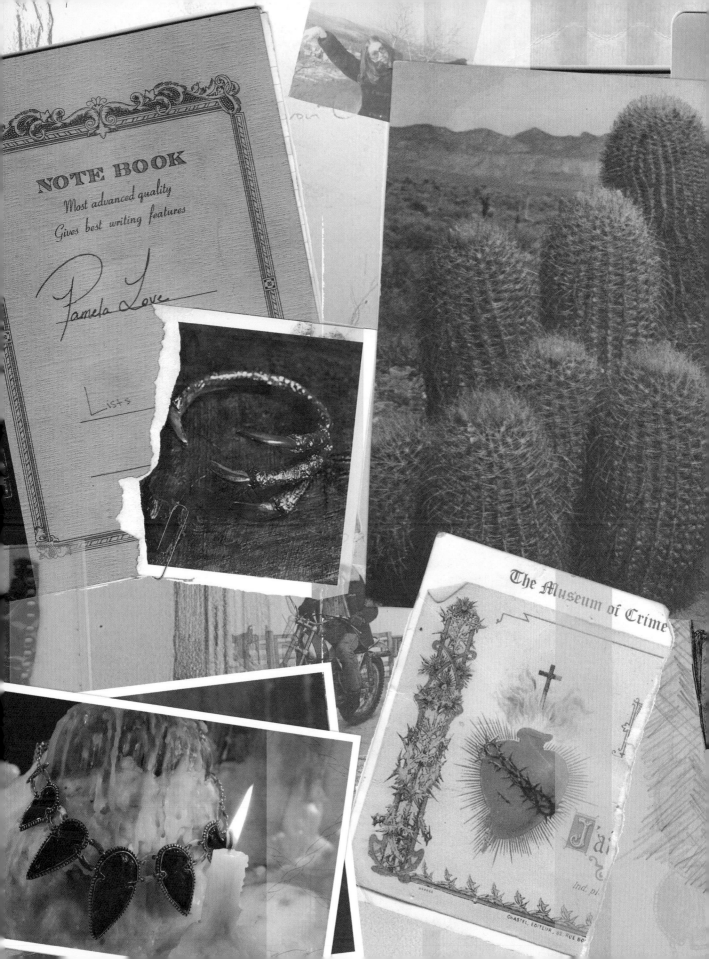

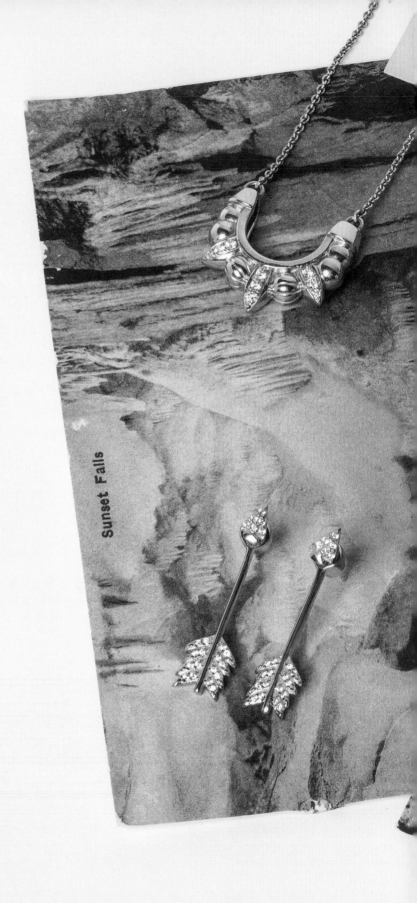

Sunset Falls

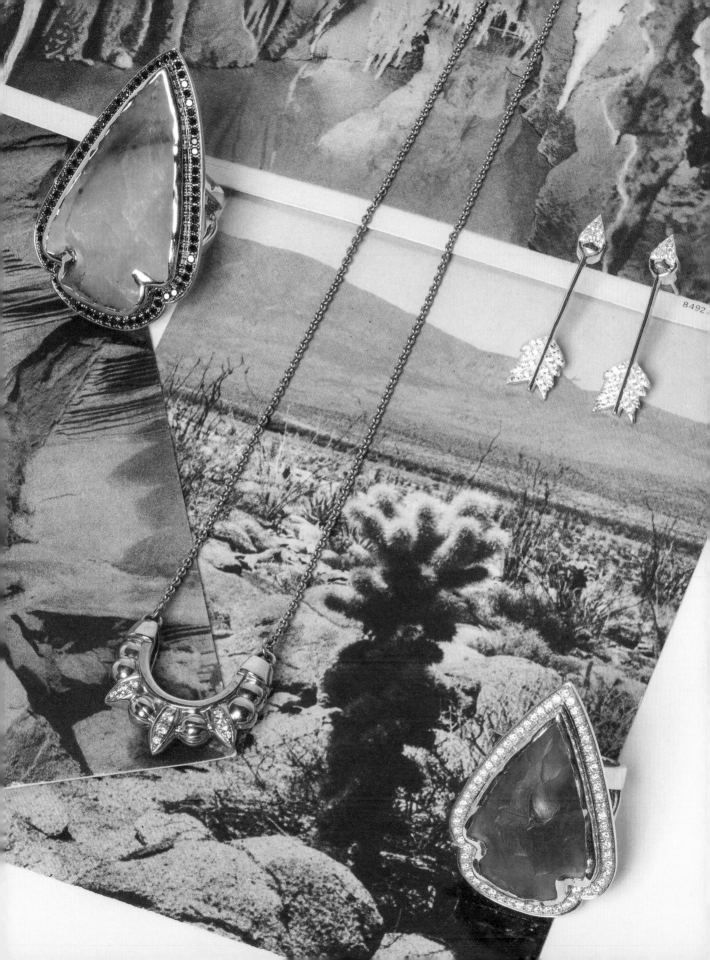

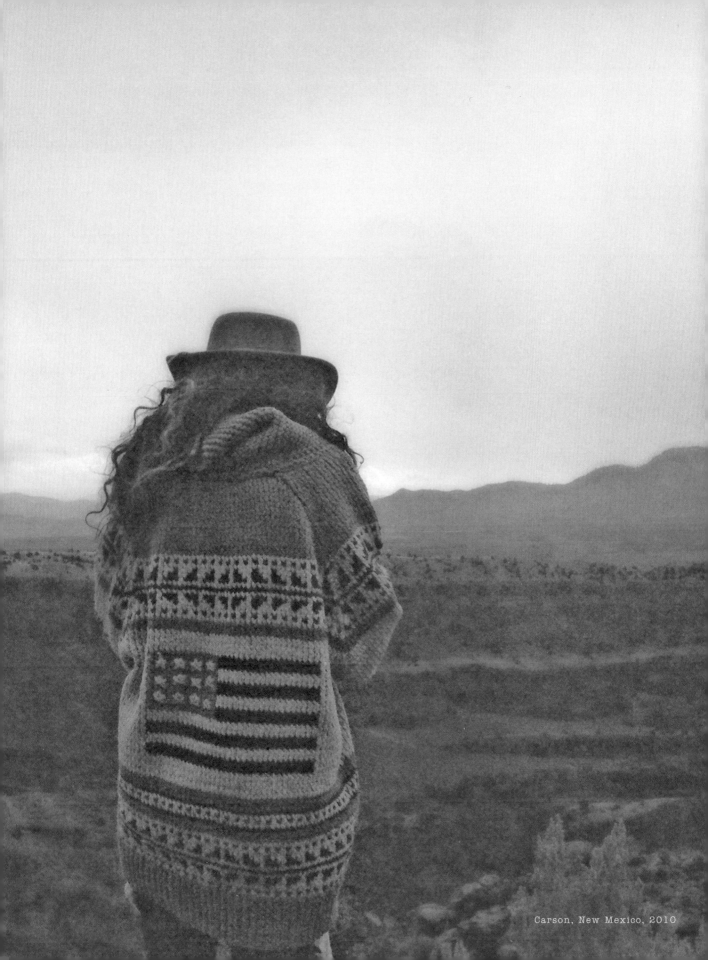

Carson, New Mexico, 2010

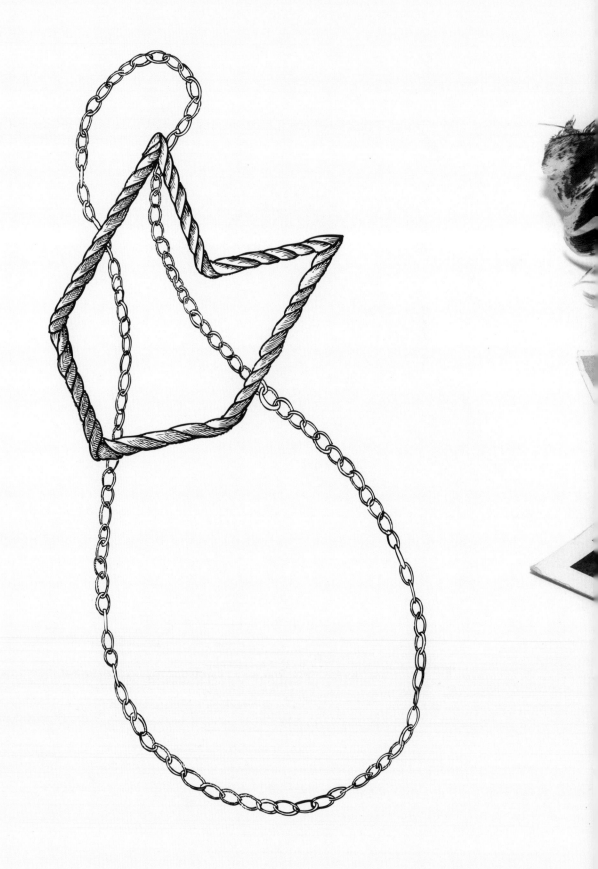

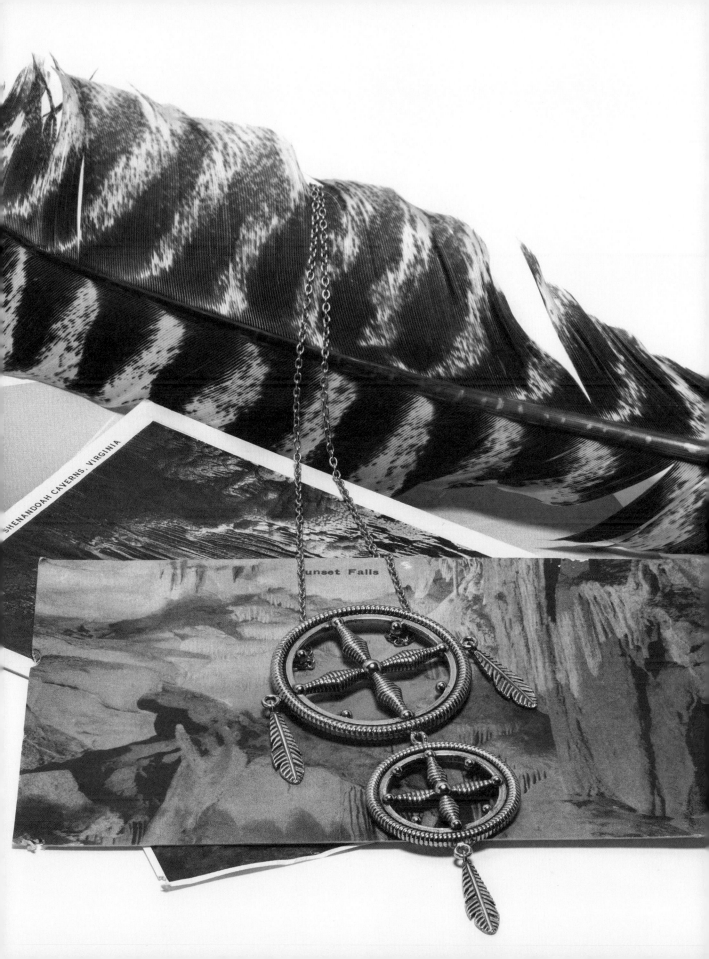

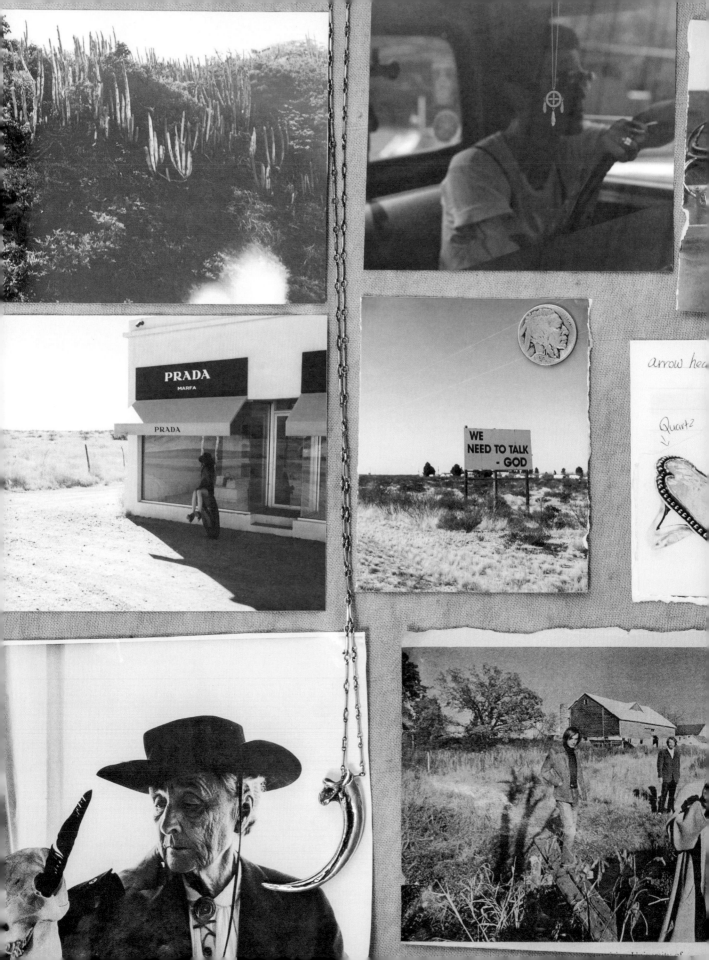

PRADA
MARFA
PRADA

WE
NEED TO TALK
- GOD

arrow hea

Quartz

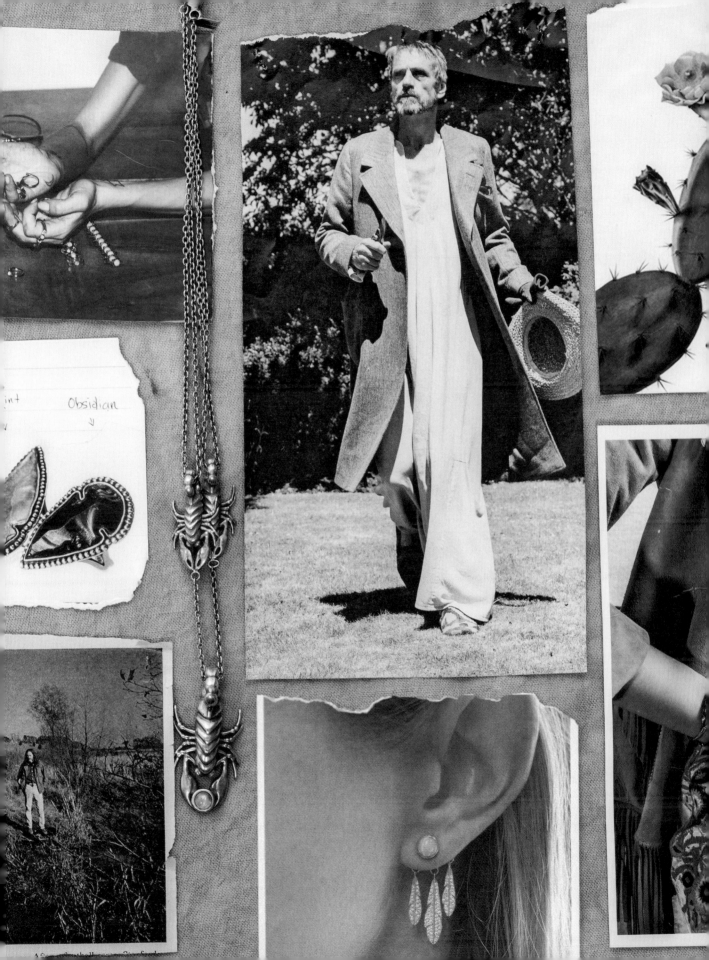

Obsidian

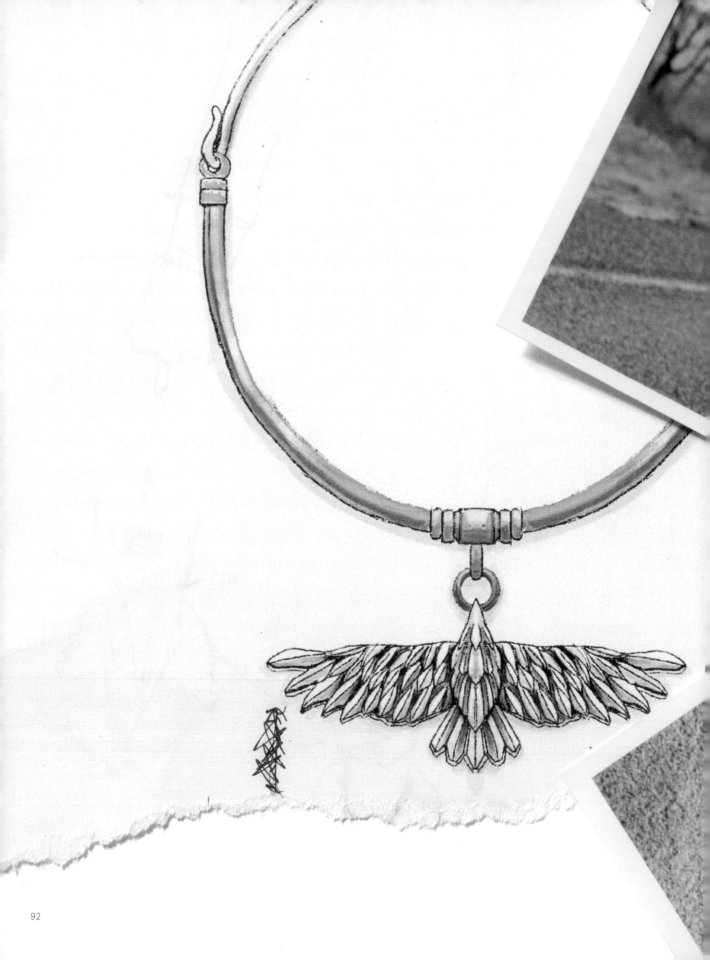

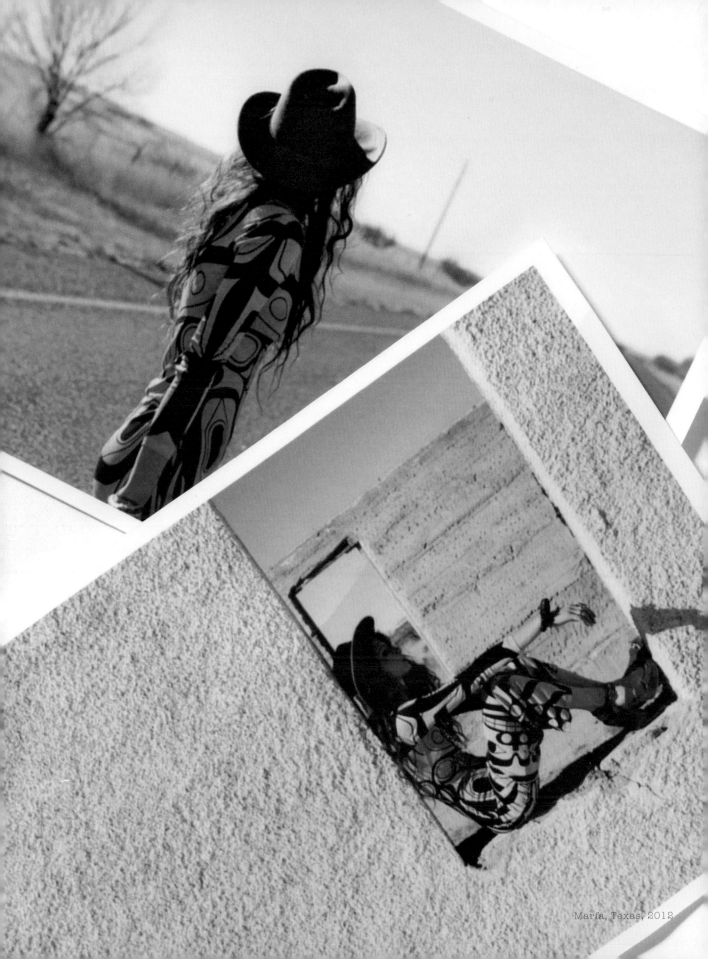

Marfa, Texas, 2012

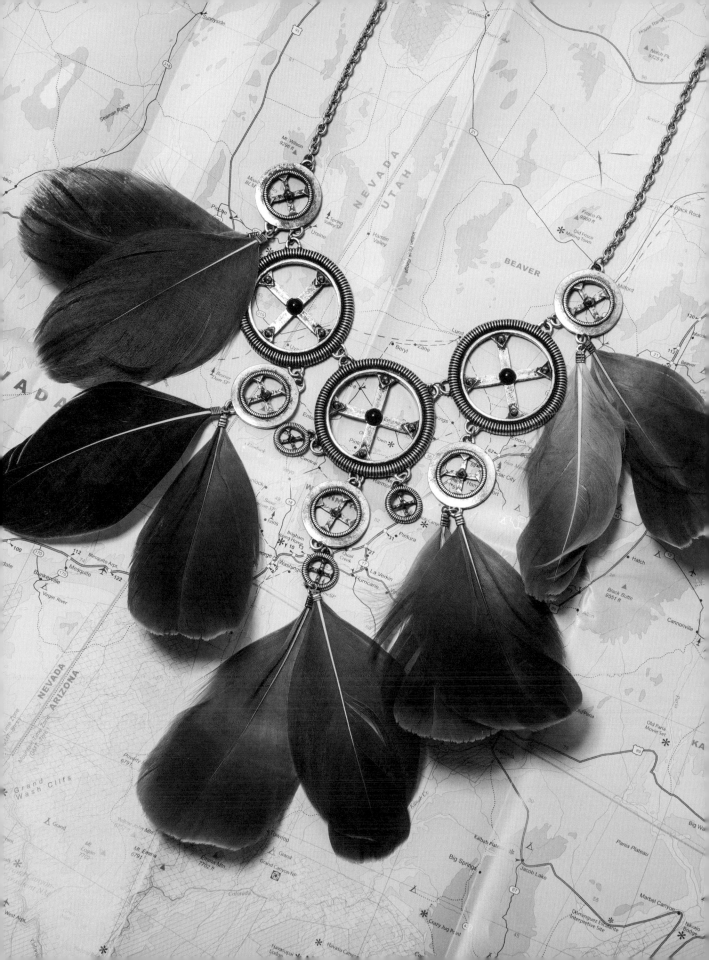

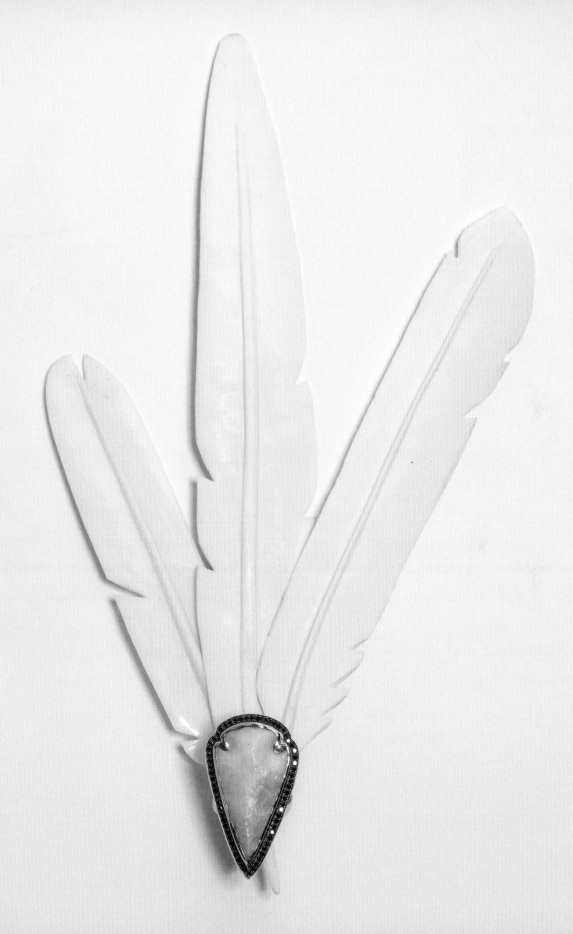

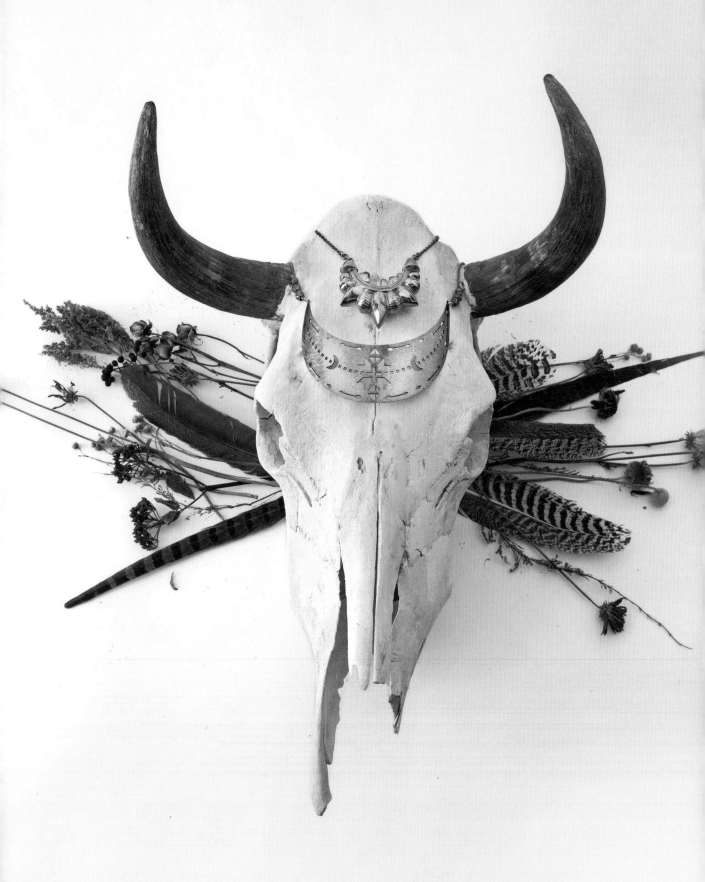

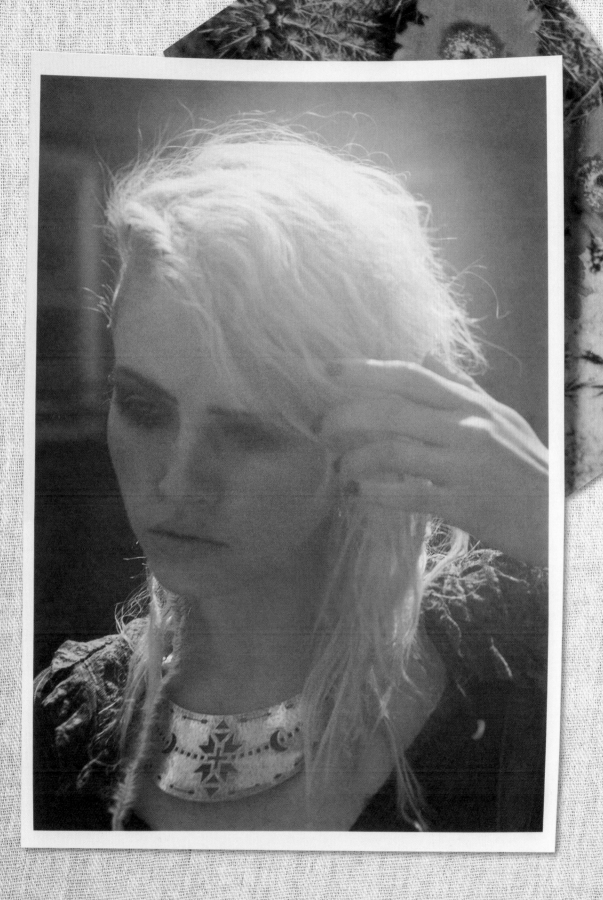

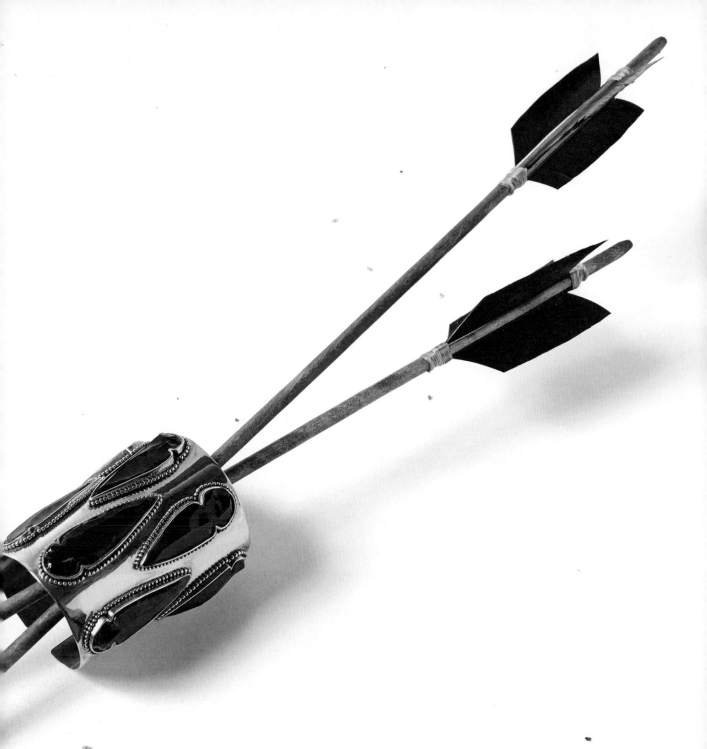

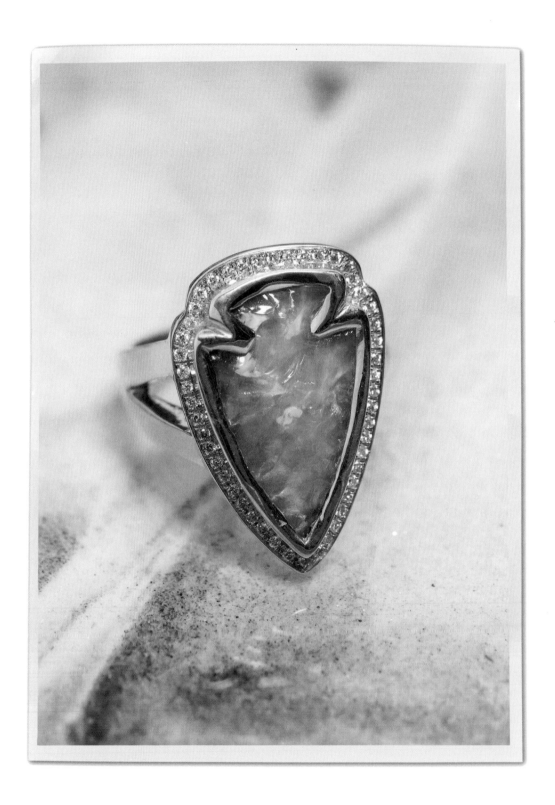

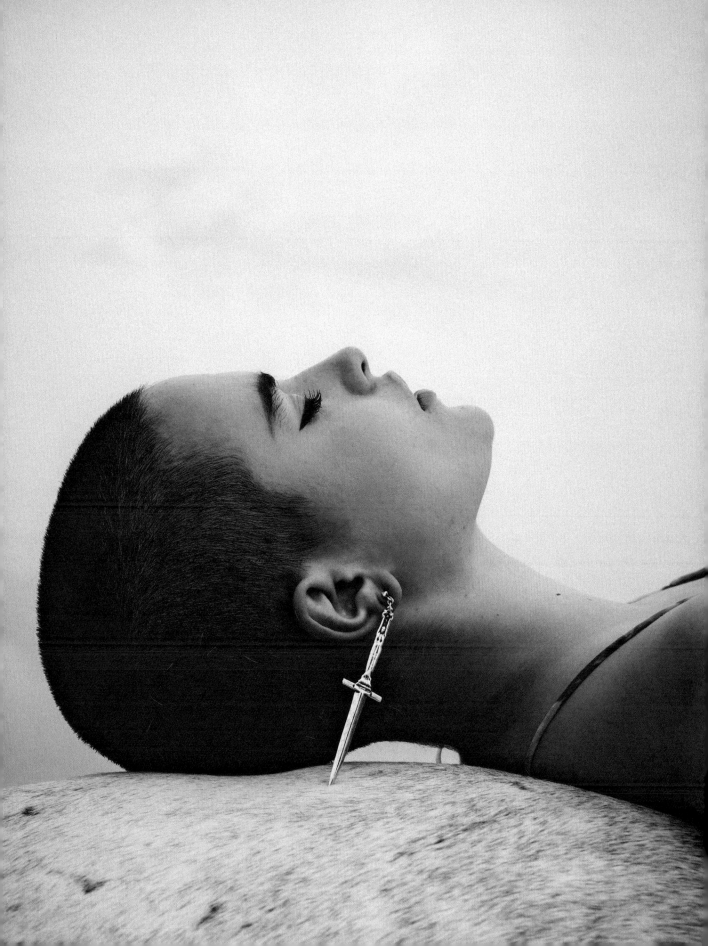

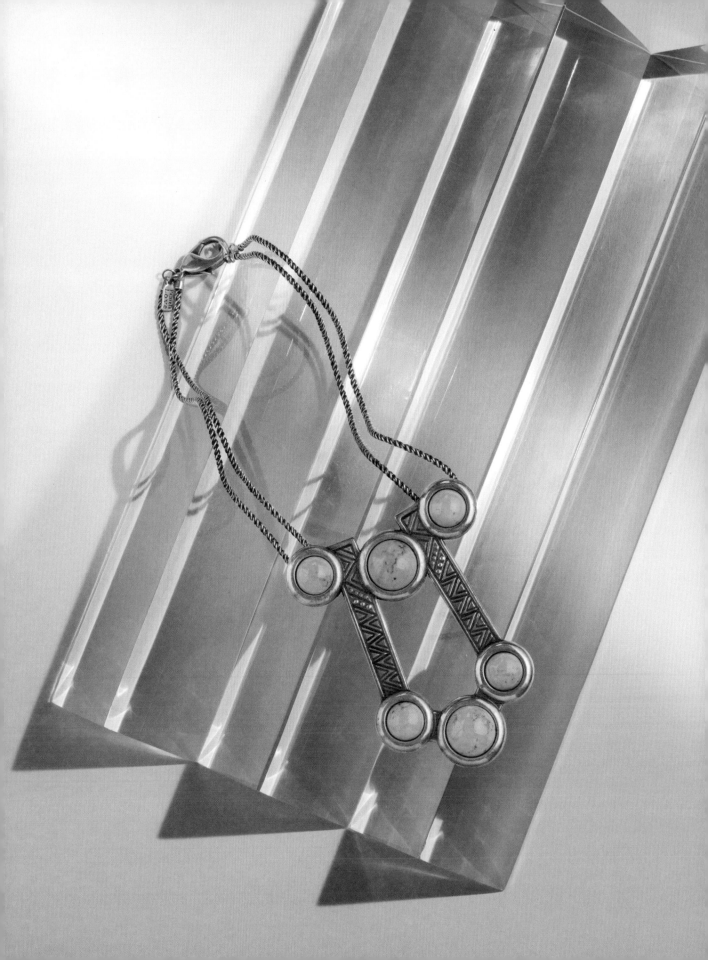

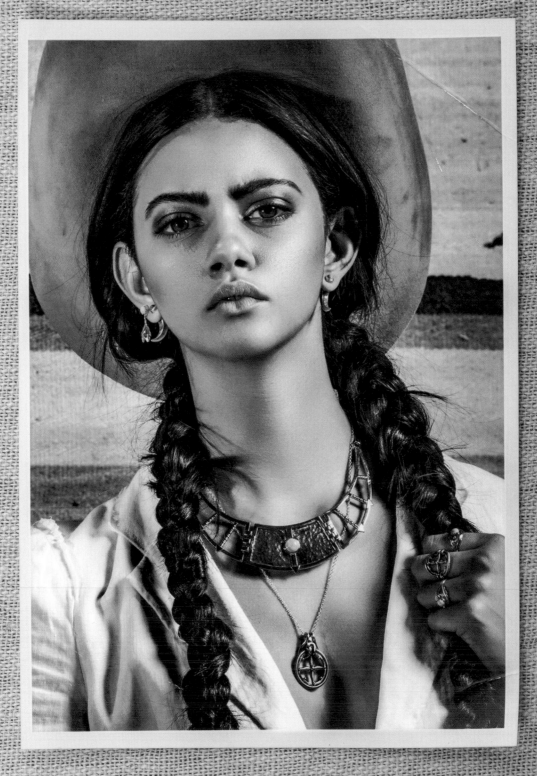

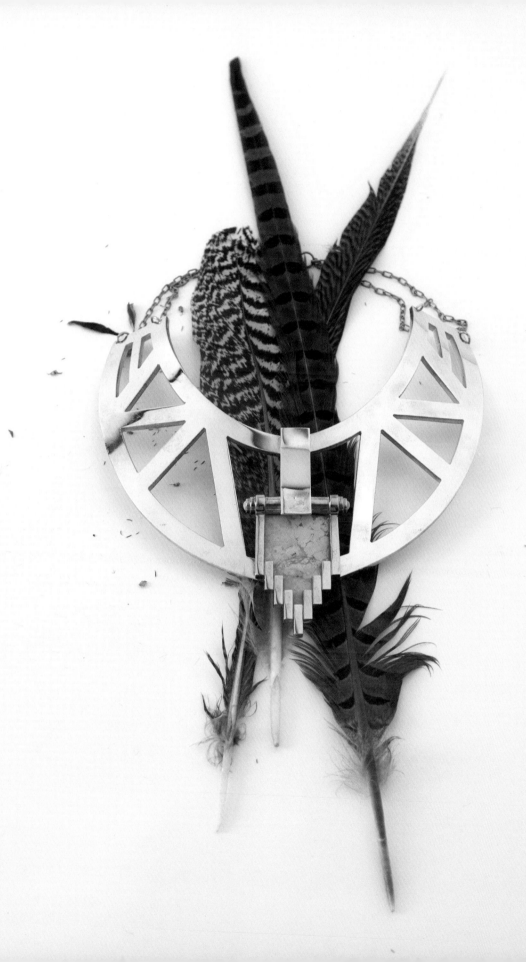

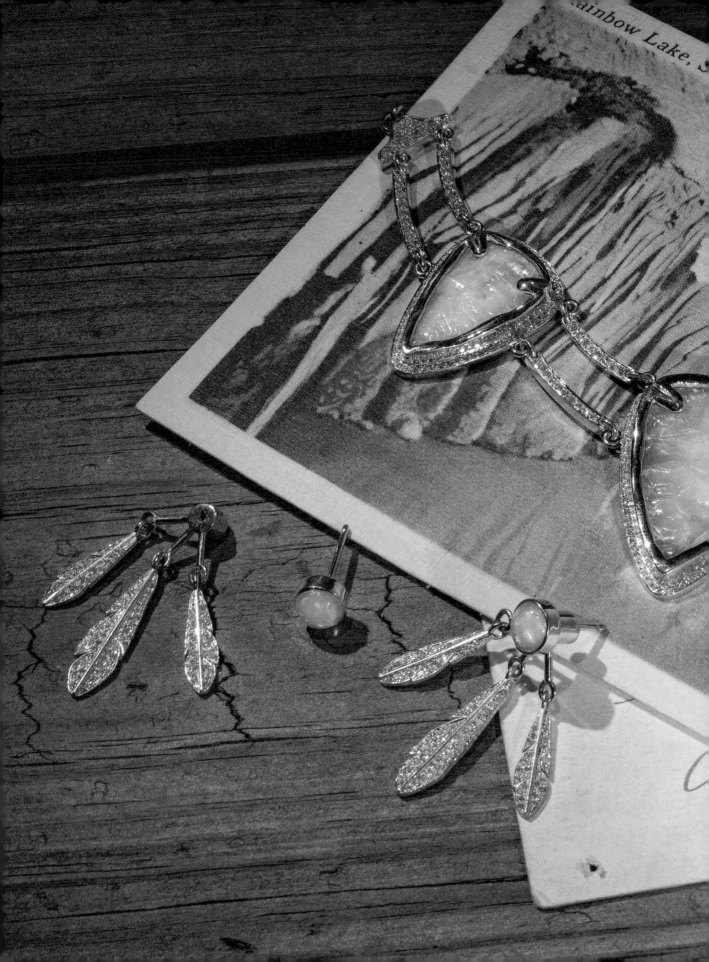

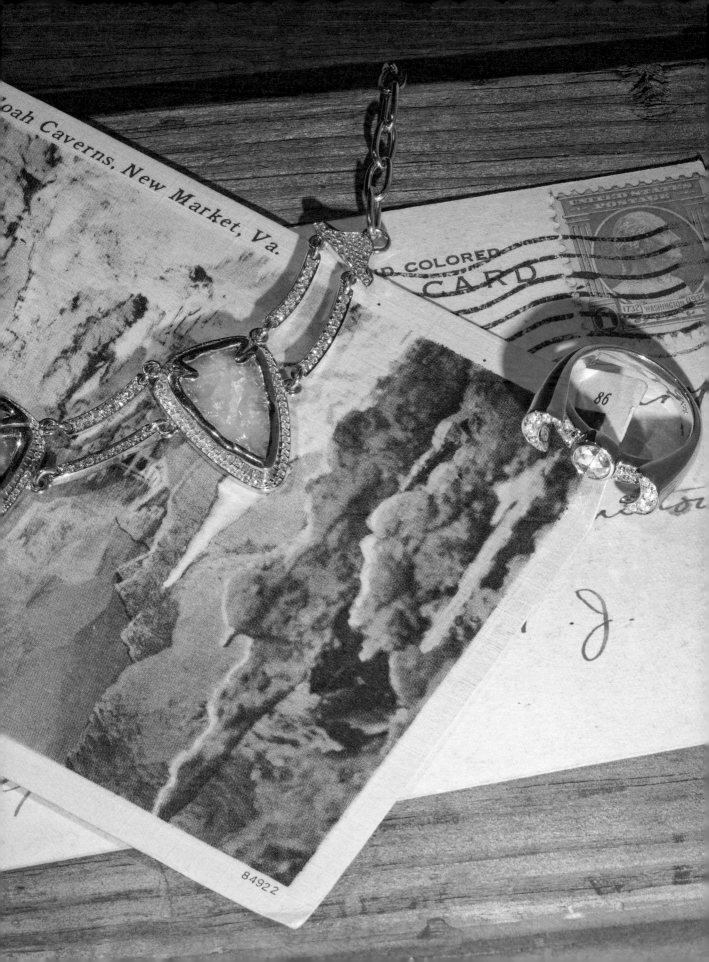

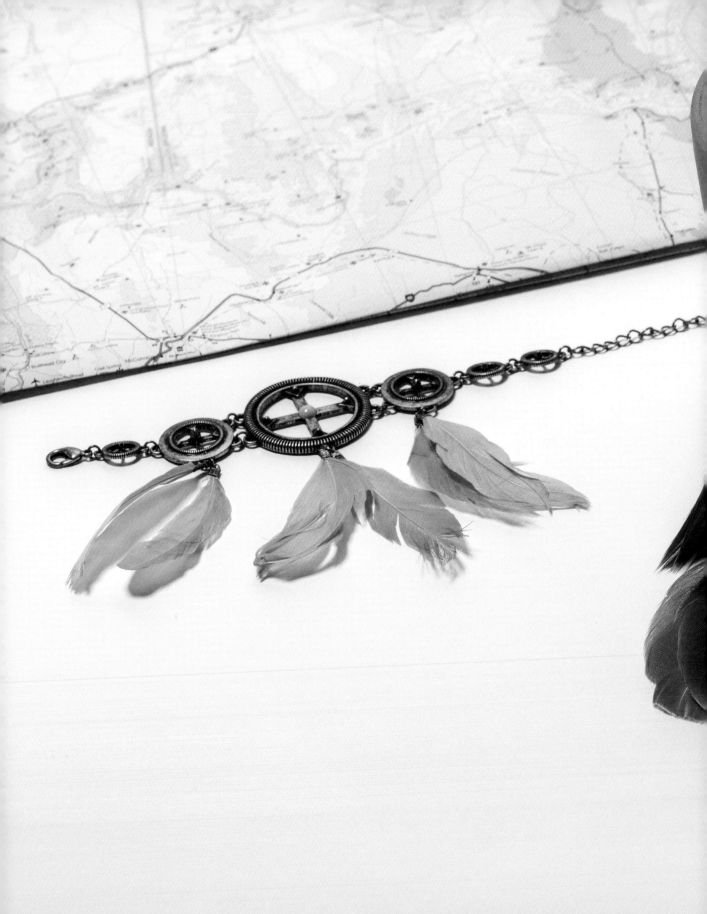

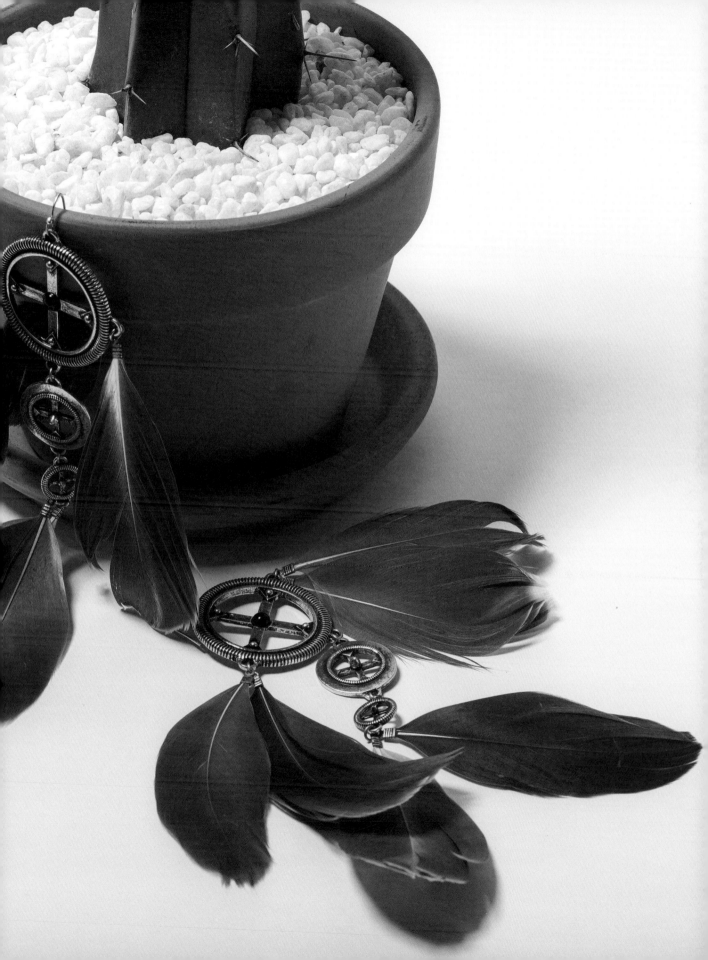

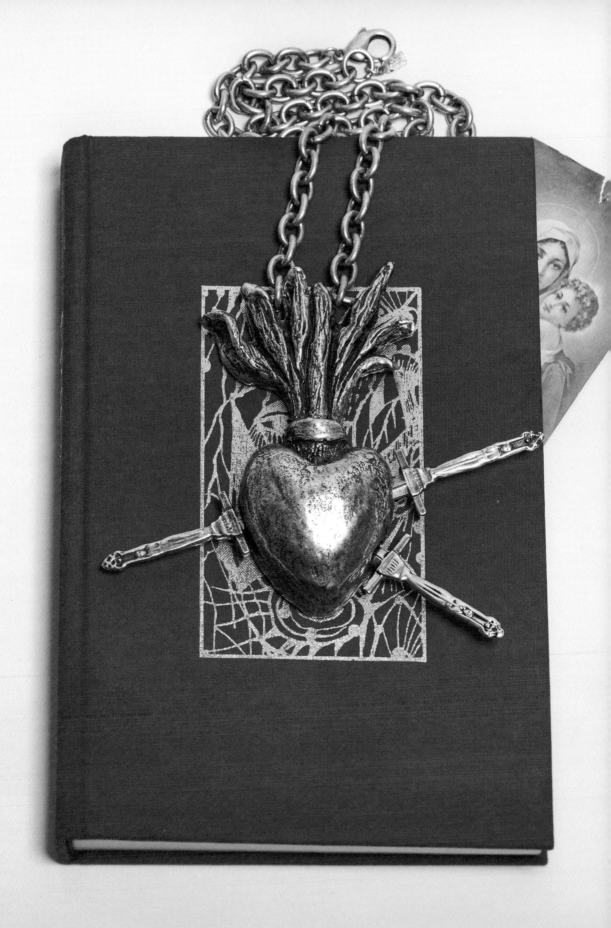

In Mexico your wishes have a dream power. When you want to see someone, he turns up.

—William S. Burroughs

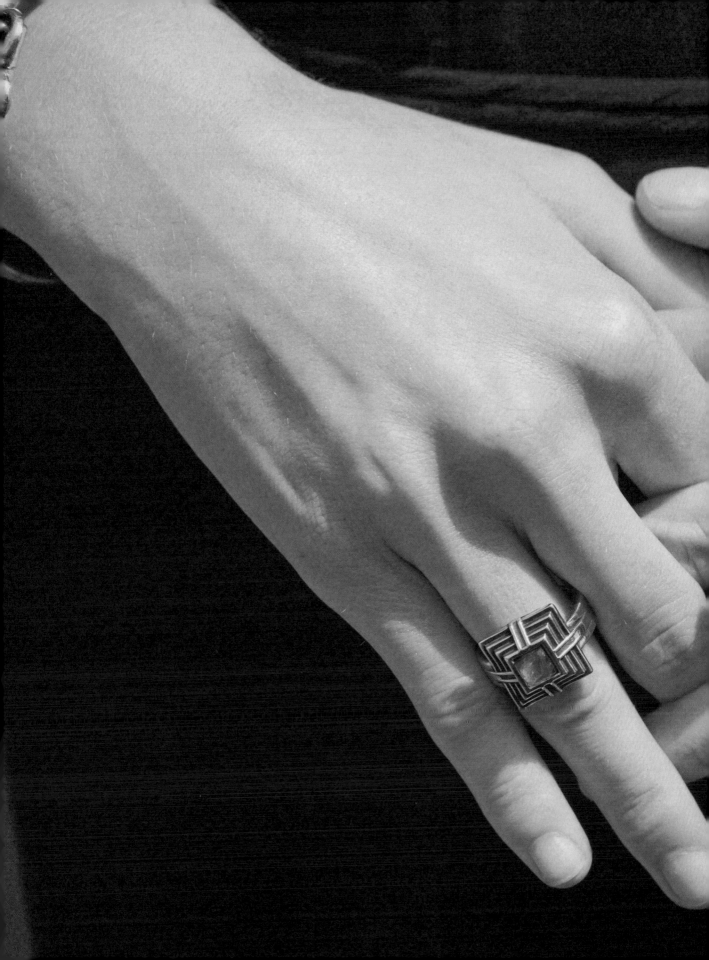

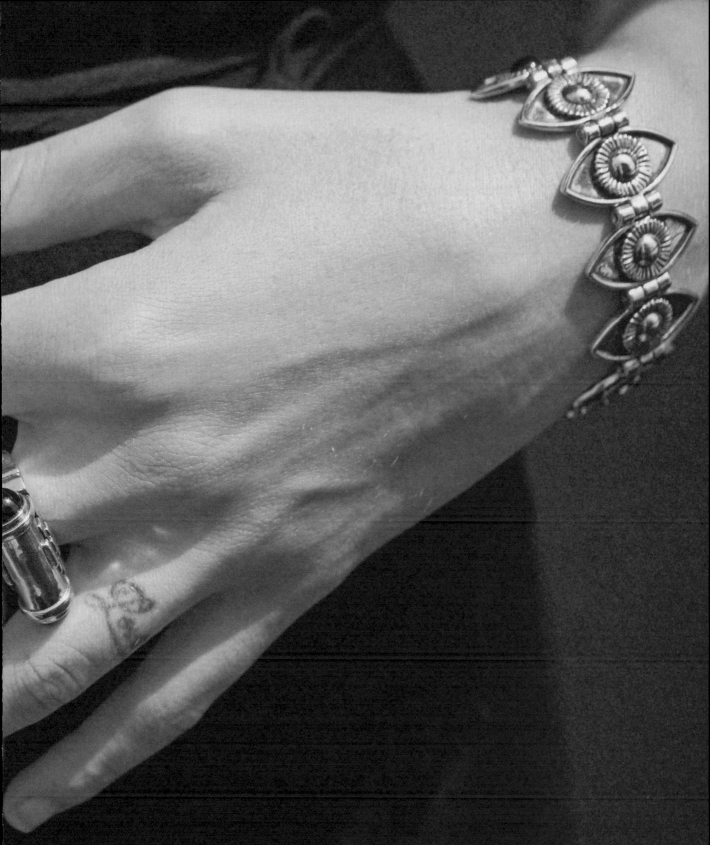

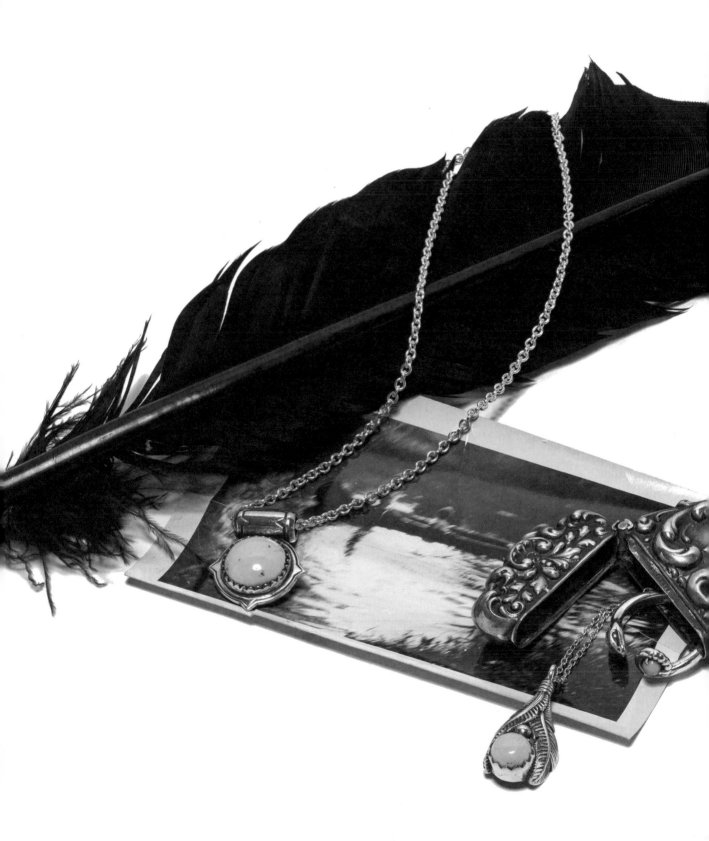

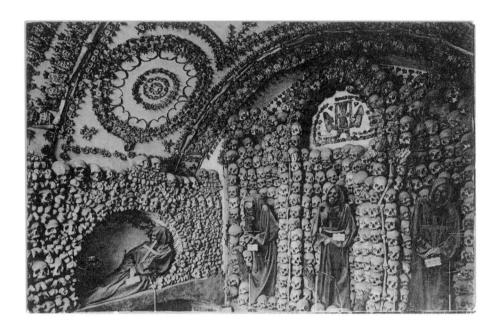

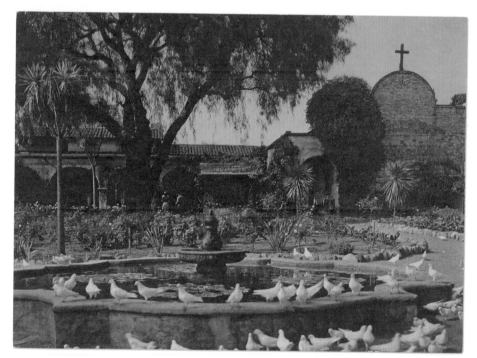

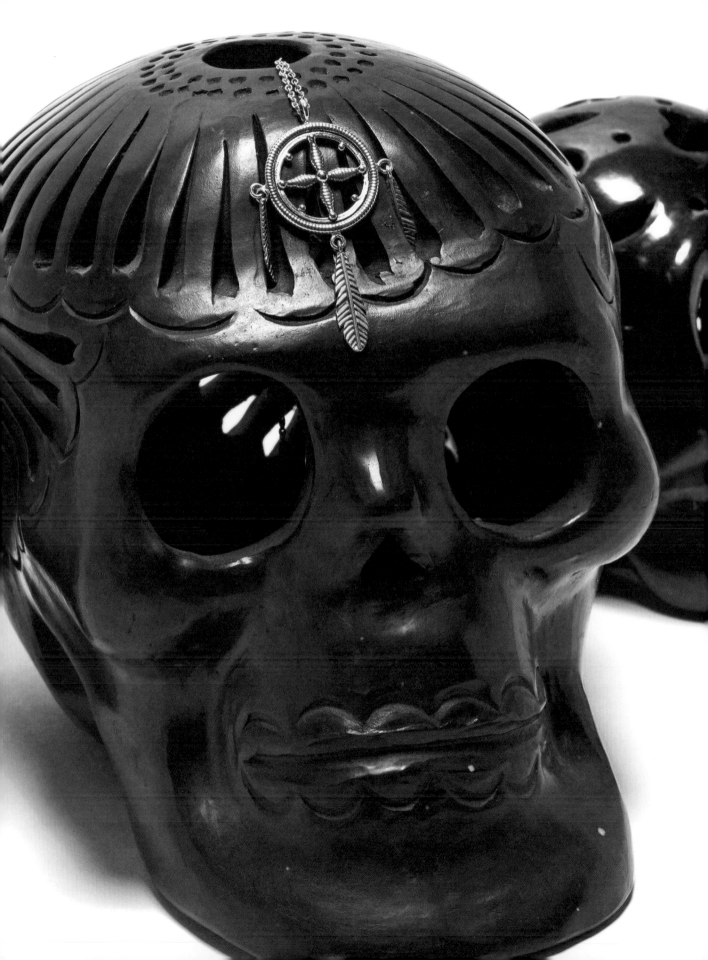

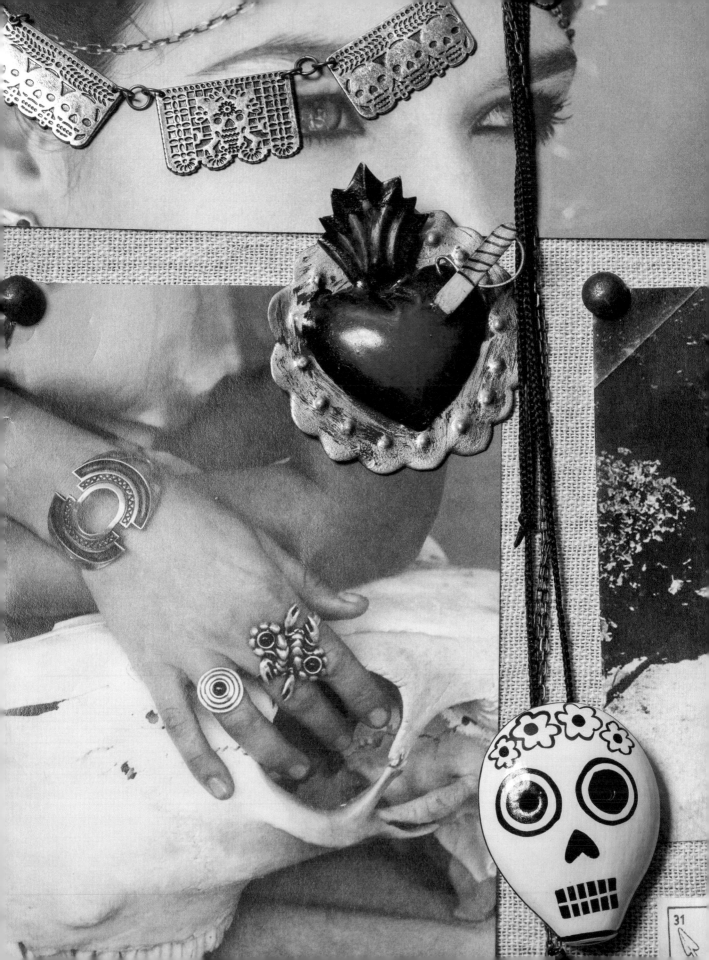

31

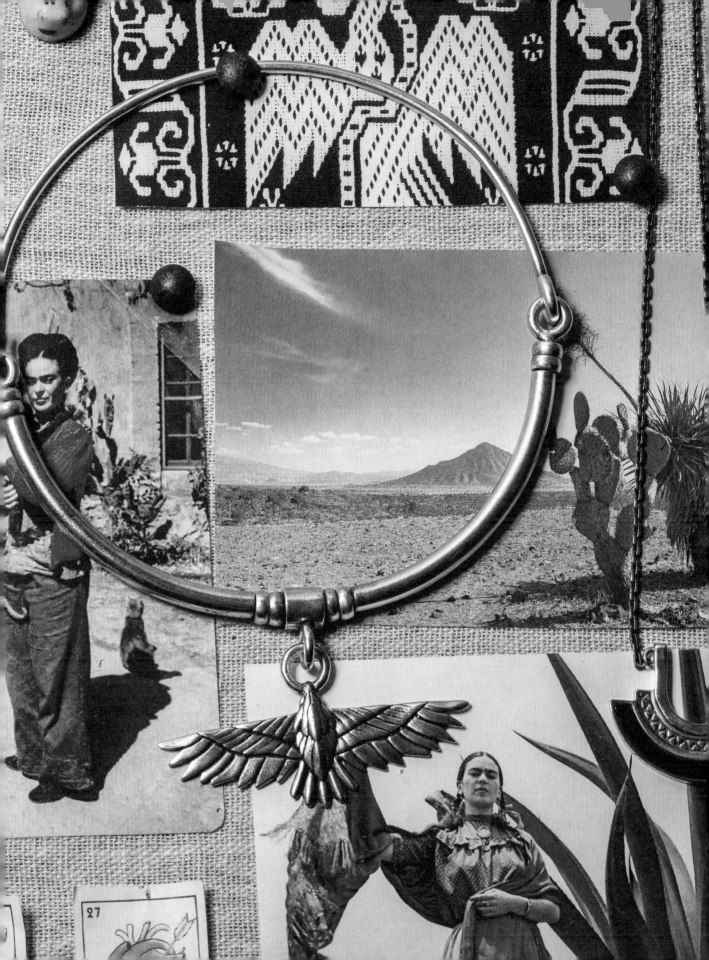

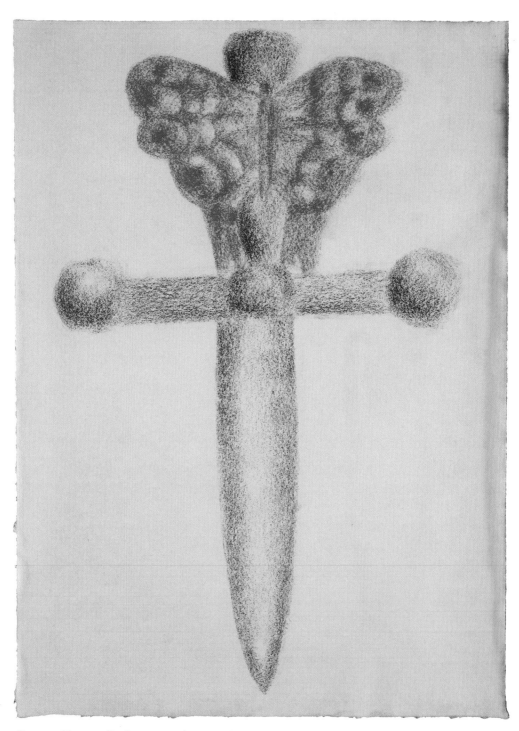

Francesco Clemente, *Si sedes non is*, pastel on paper, 2007

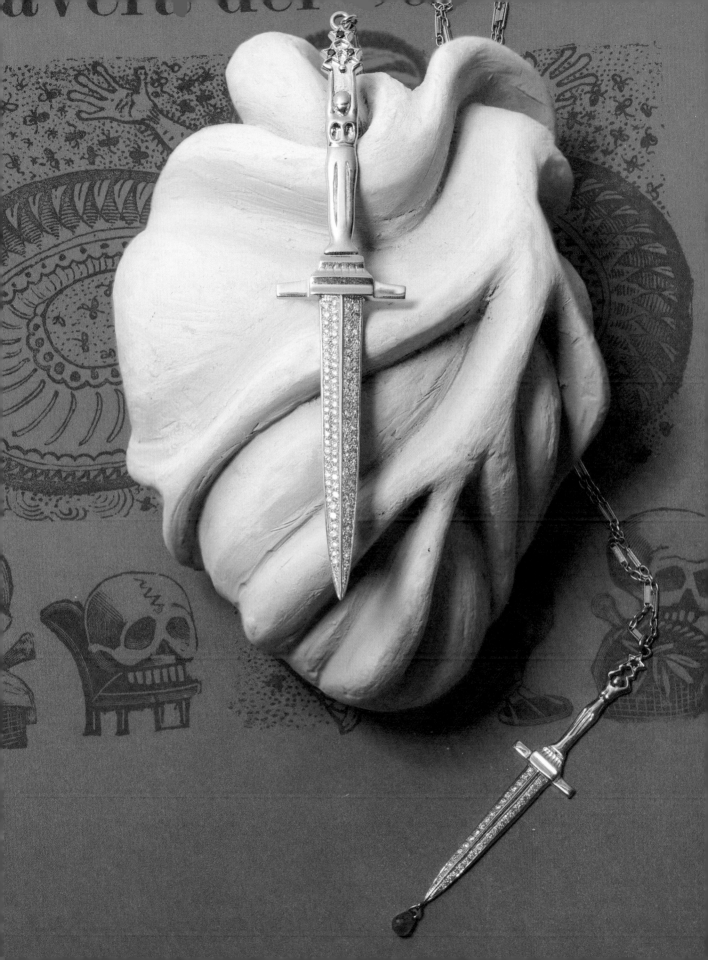

...ración. Una desespe-
ración que ninguna
palabra puede descri-
bir. Sin embargo tengo
ganas de vivir. Ya
comencé a pintar. El
cuadrito que voy a re-
galarle al Dr Farill
y que estoy haciendo
con todo mi cariño pa-
ra él. Tengo mu...
inquietud en el...
de mi pintura...

to re...
...istó...
...no h...
...la...

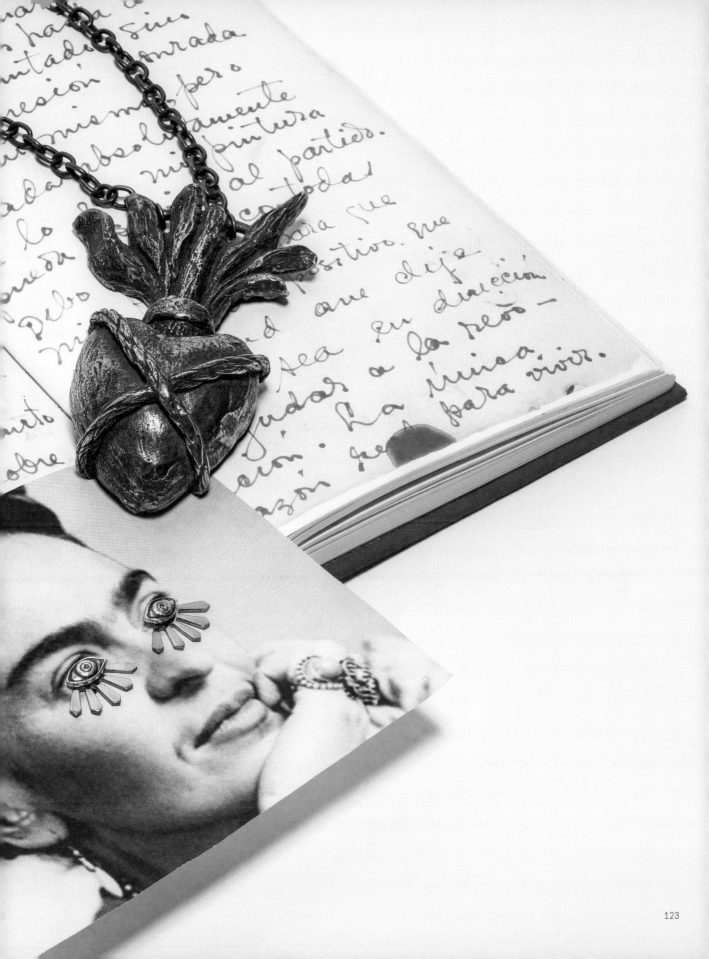

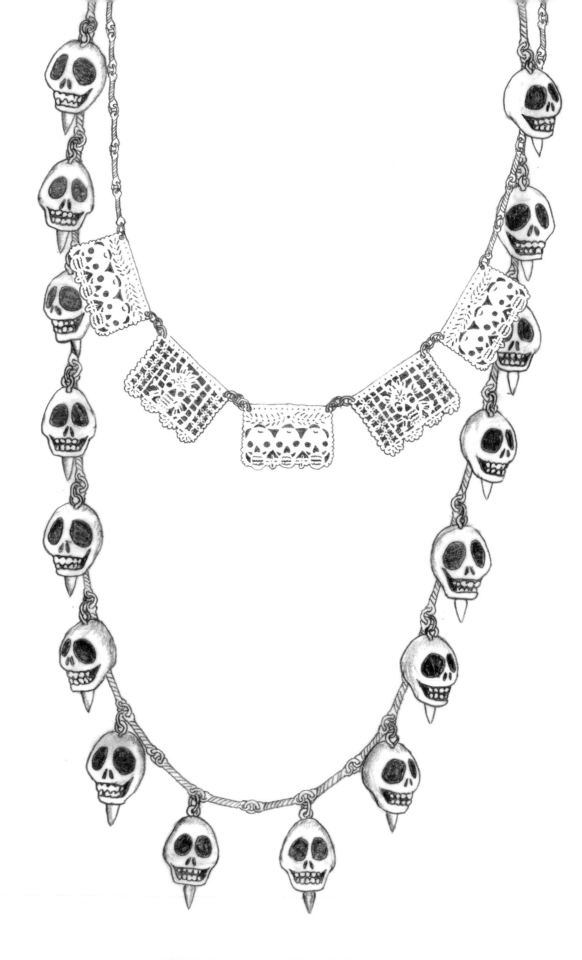

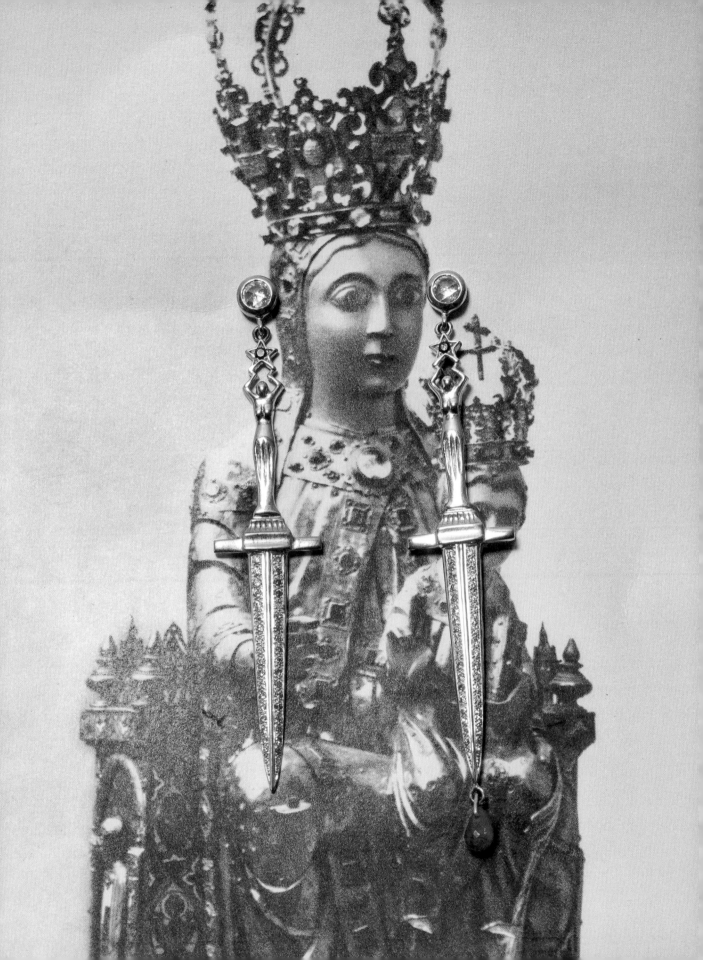

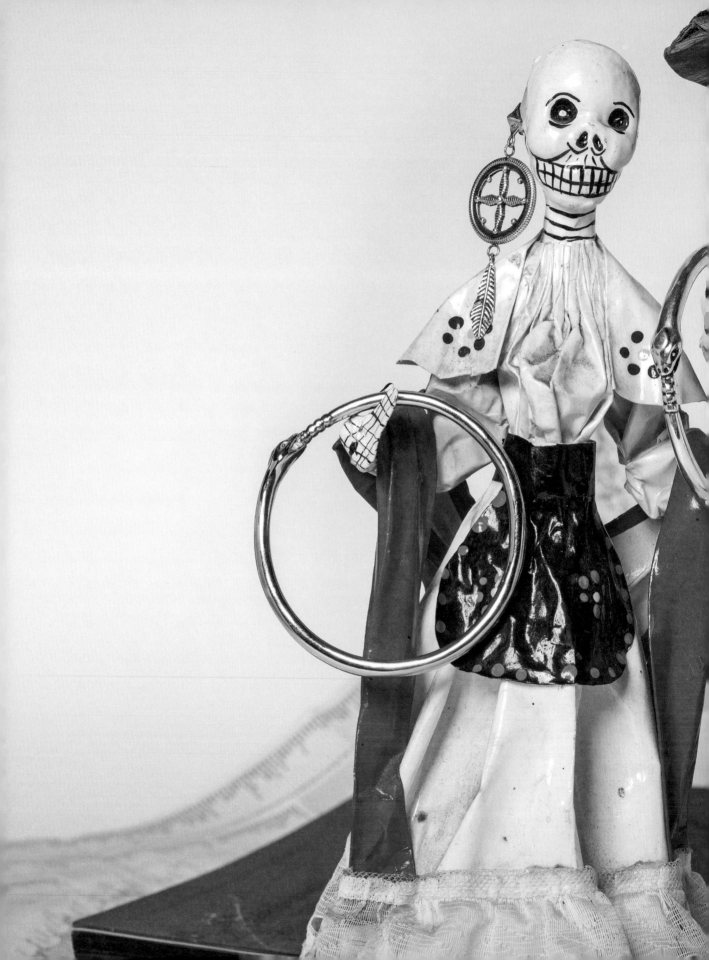

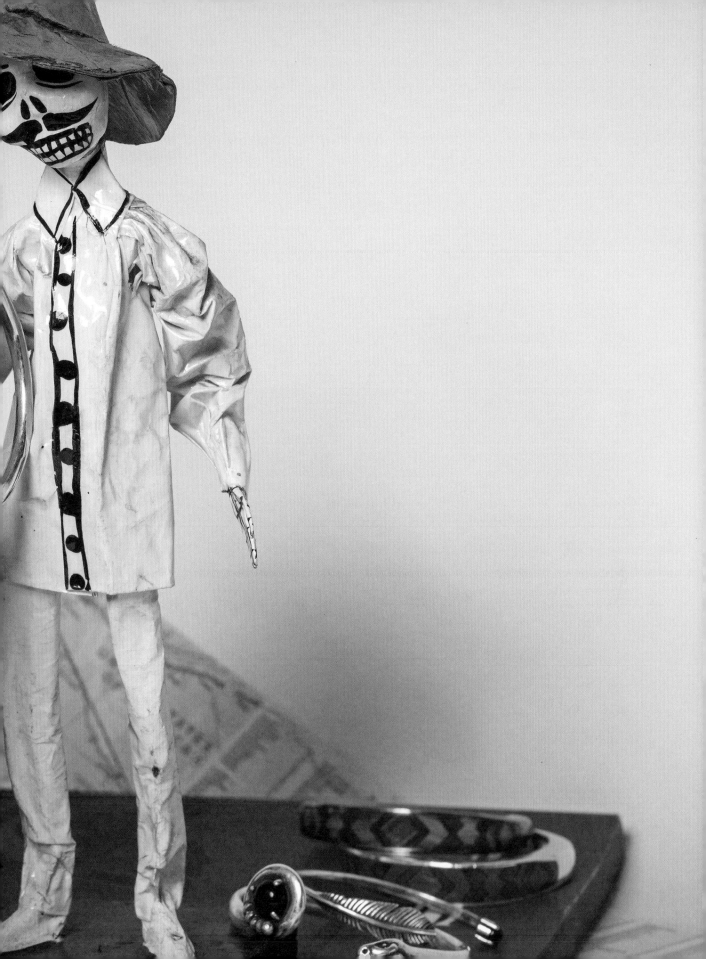

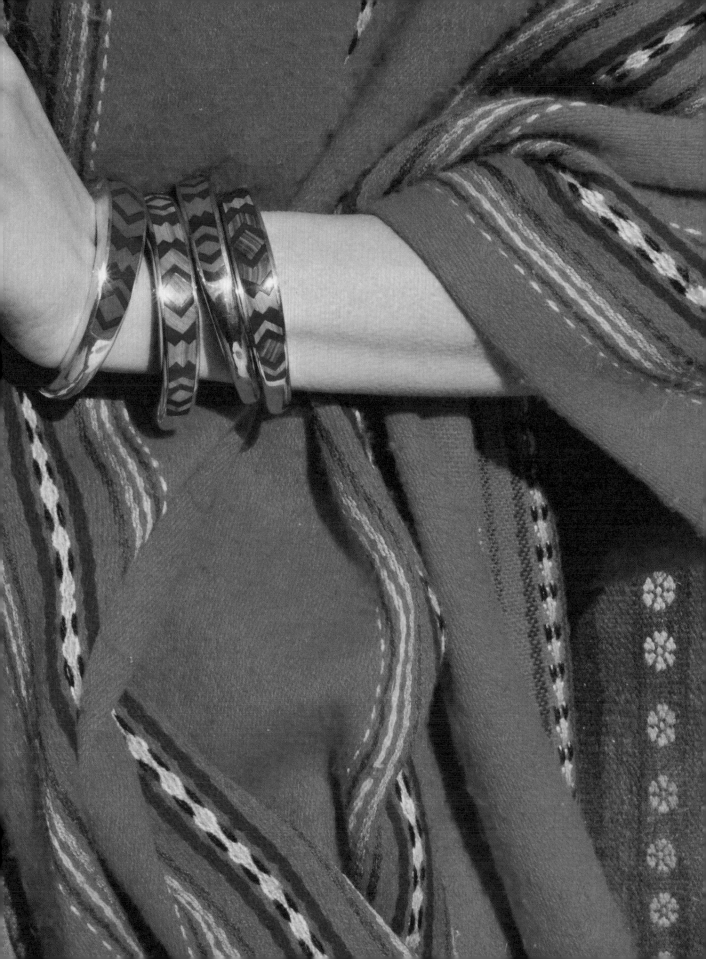

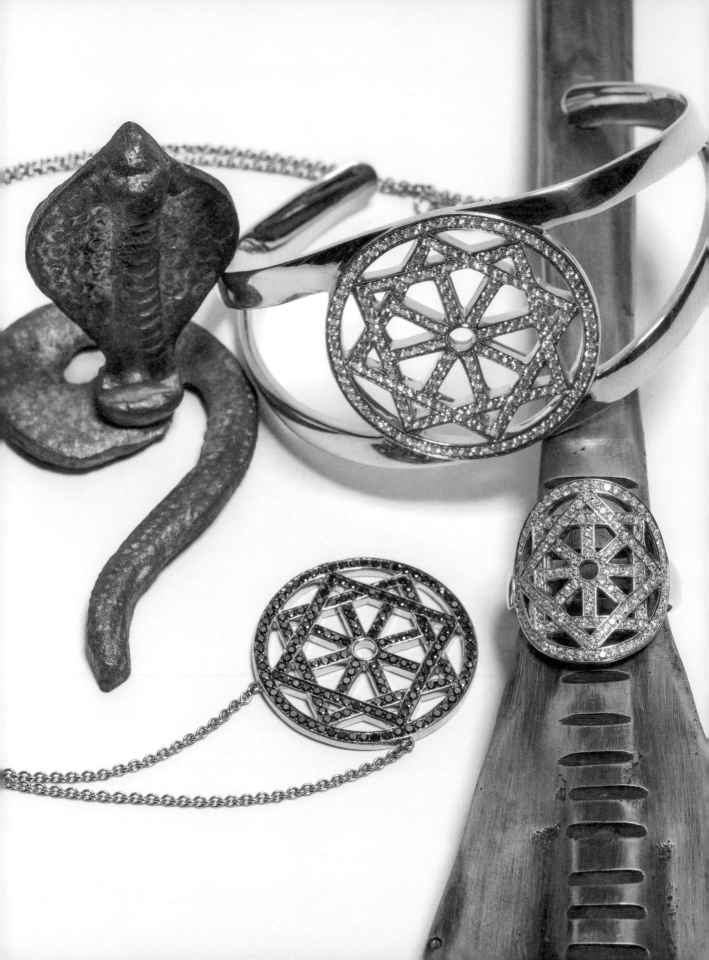

Travel makes one modest—you
see what a tiny place you
occupy in the world.

—Gustave Flaubert

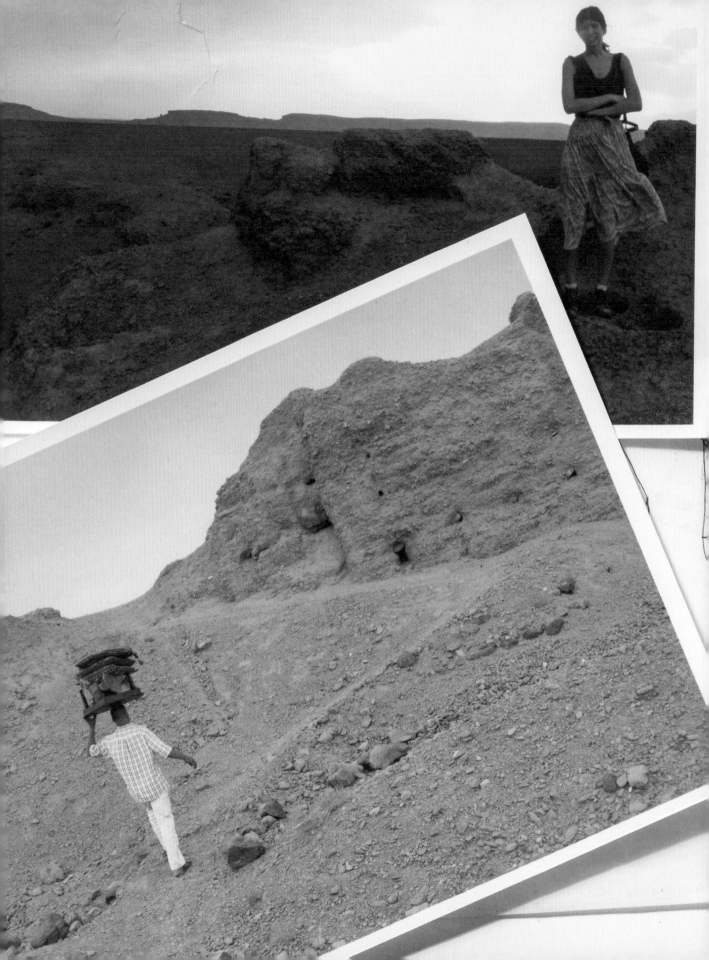

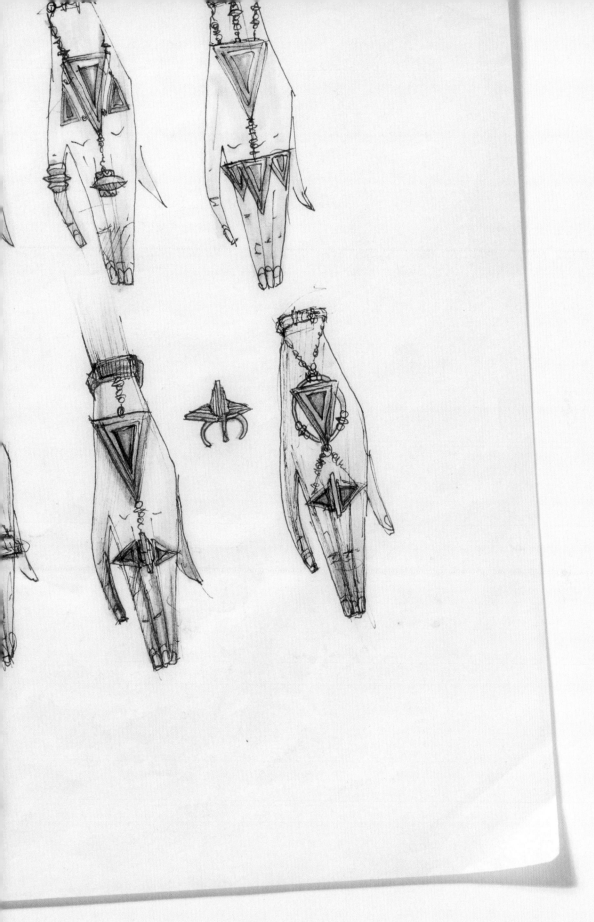

Morocco, 2012

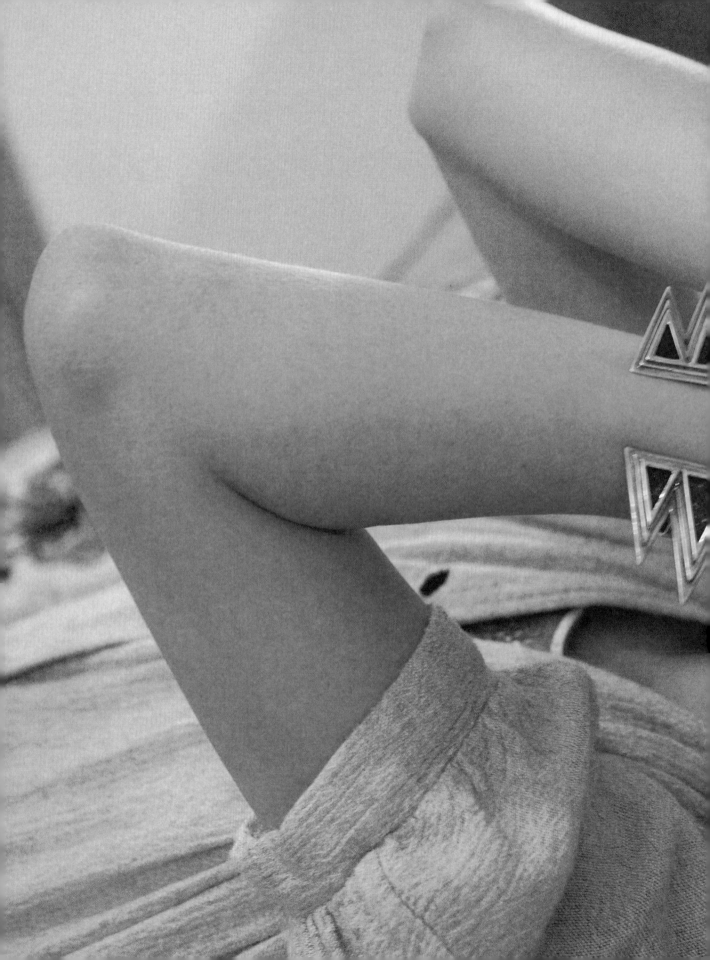

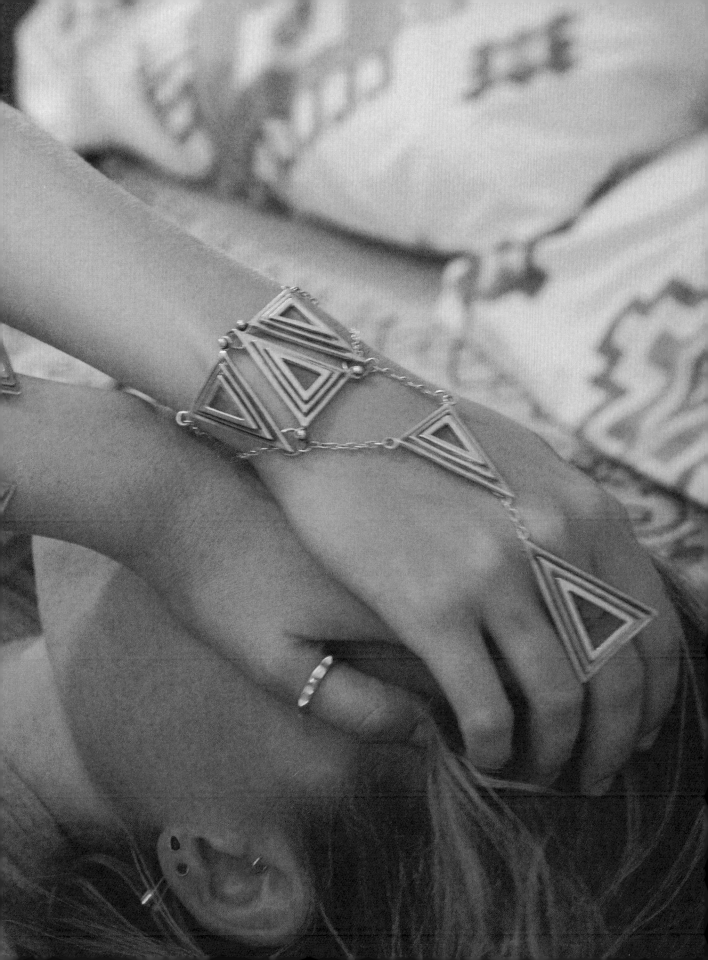

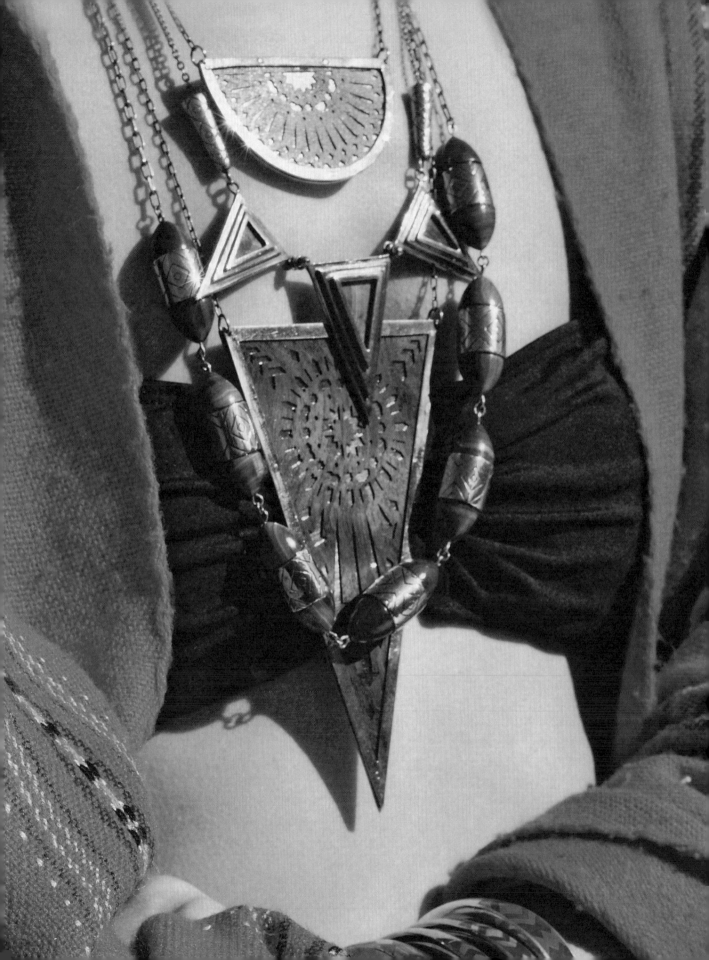

Morocco, 2012

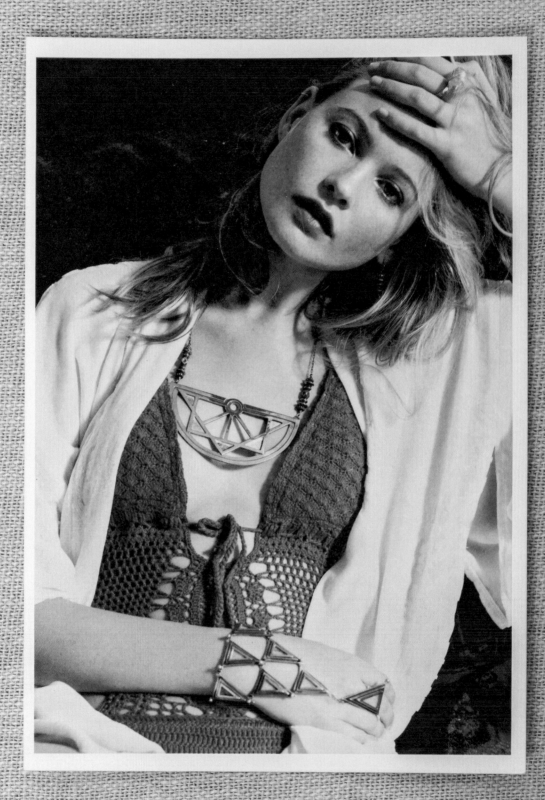

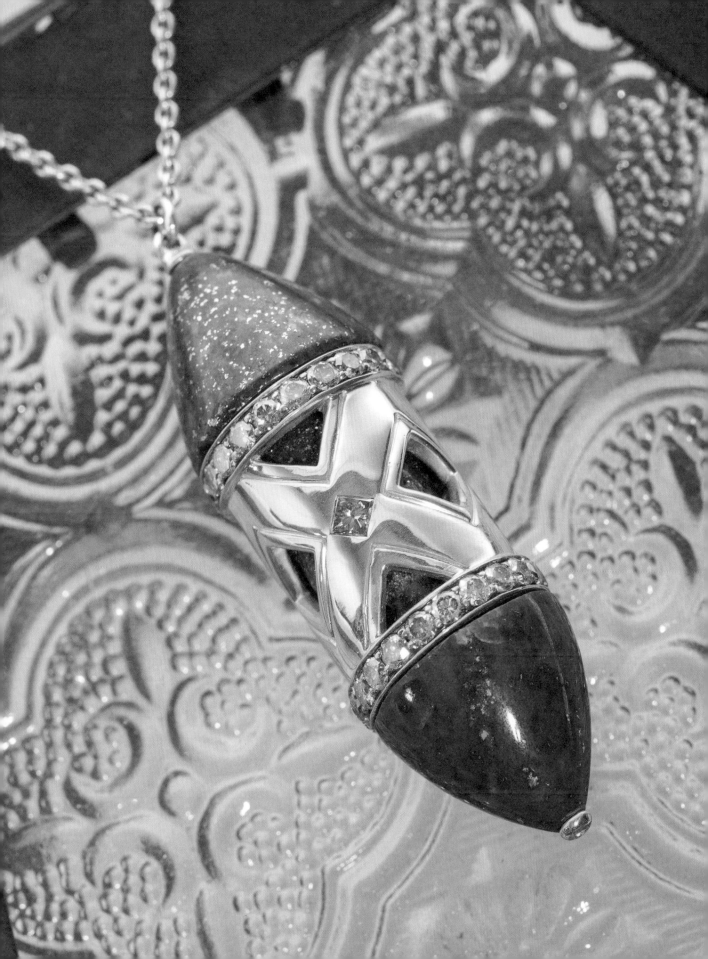

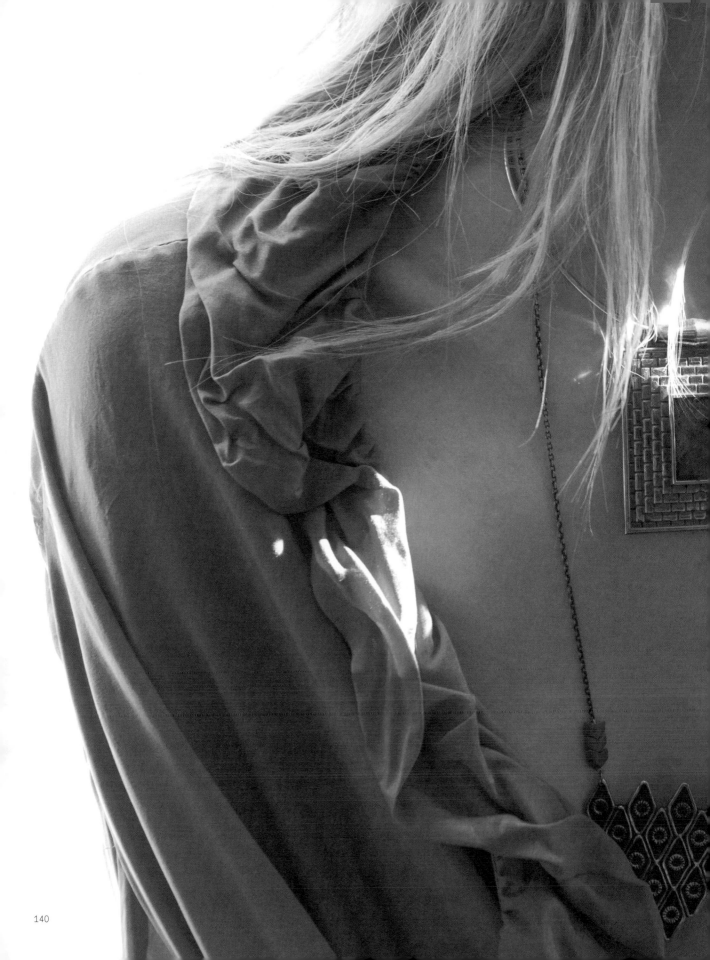

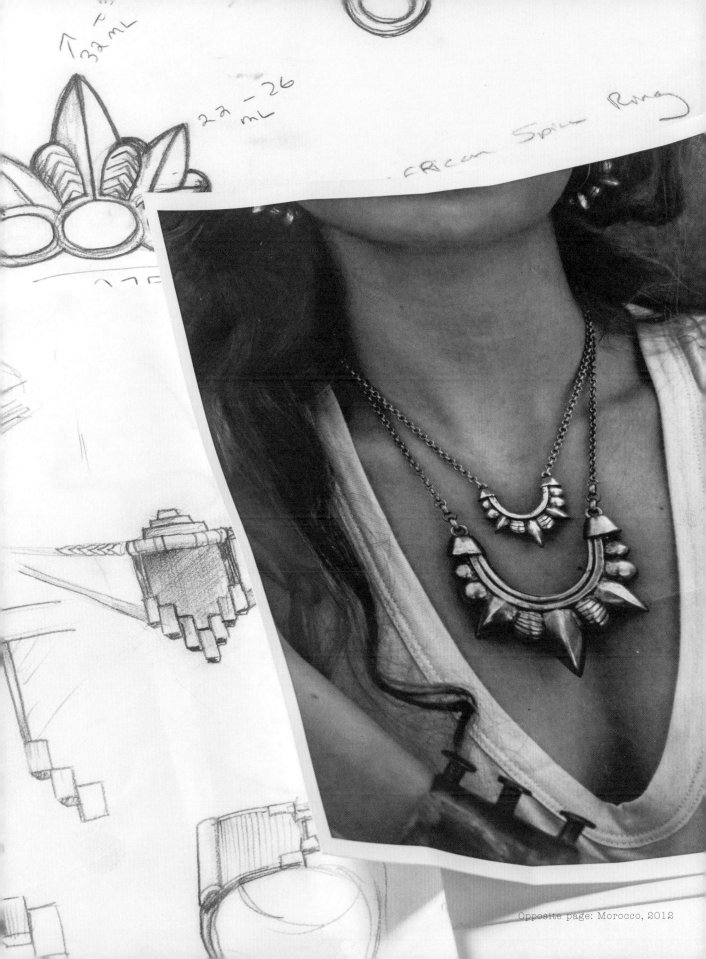

African Spike Ring

32 mL
2a - 26 mL

Opposite page: Morocco, 2012

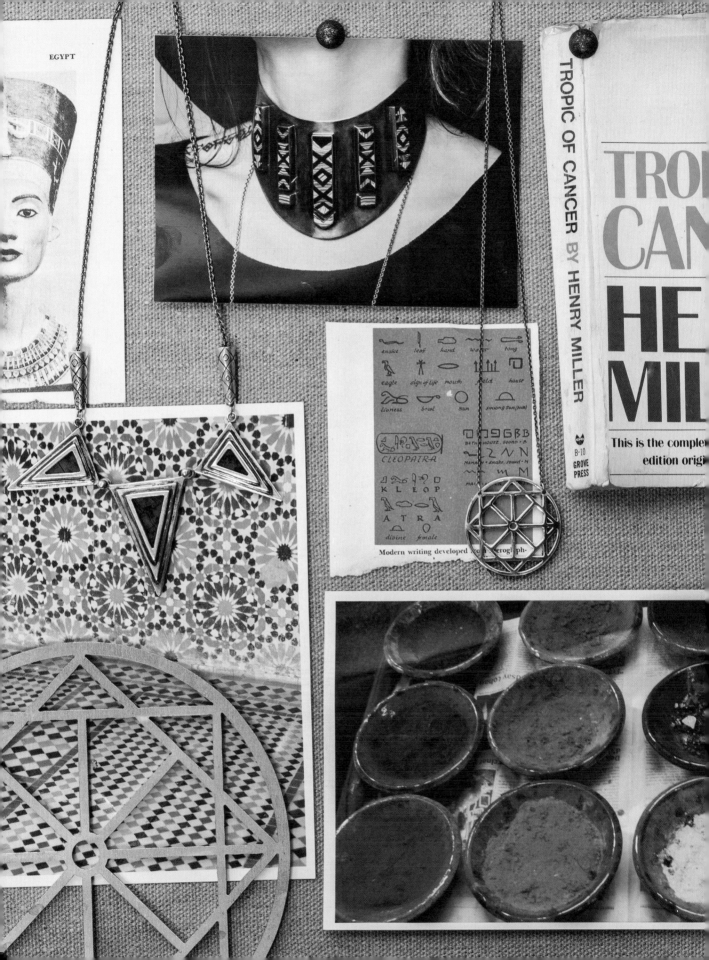

ARCADIA

PRIMITIVE ARCHES

ROMAN

GOTHIC

TUDOR

ARABIC

OF
ER
RY
ER

ed Grove Press
at $7.50

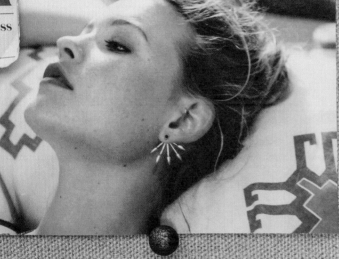

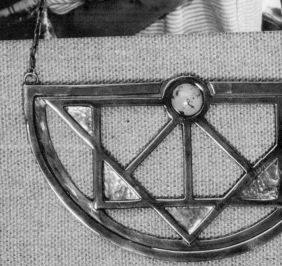

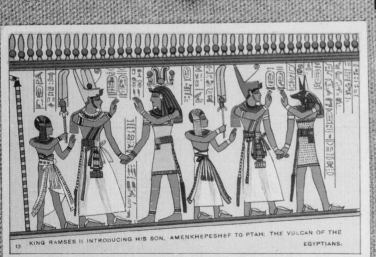

KING RAMSES II INTRODUCING HIS SON, AMENKHEPESHEF TO PTAH: THE VULCAN OF THE
EGYPTIANS.

13

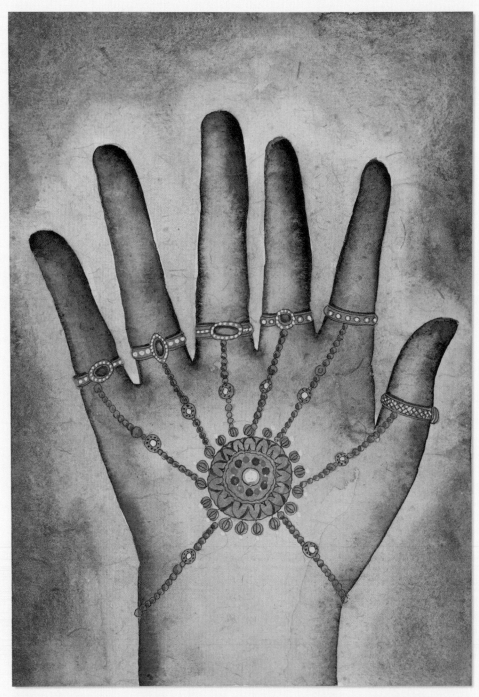

Francesco Clemente, *Emblems of Transformations 76*, watercolor and miniature on handmade paper, 2014

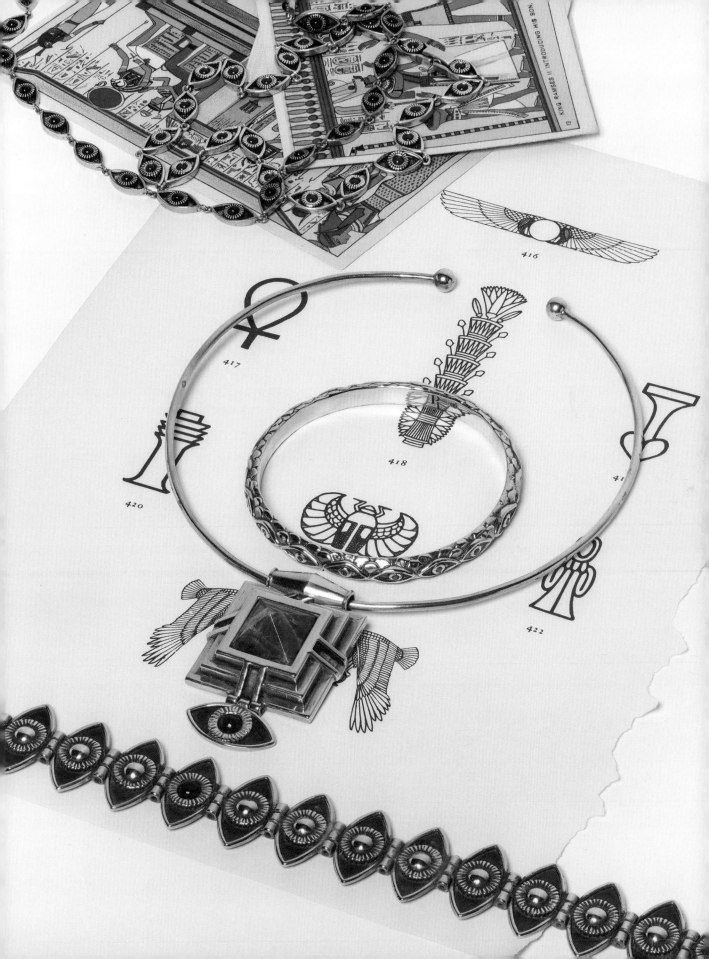

416

417

418

420

422

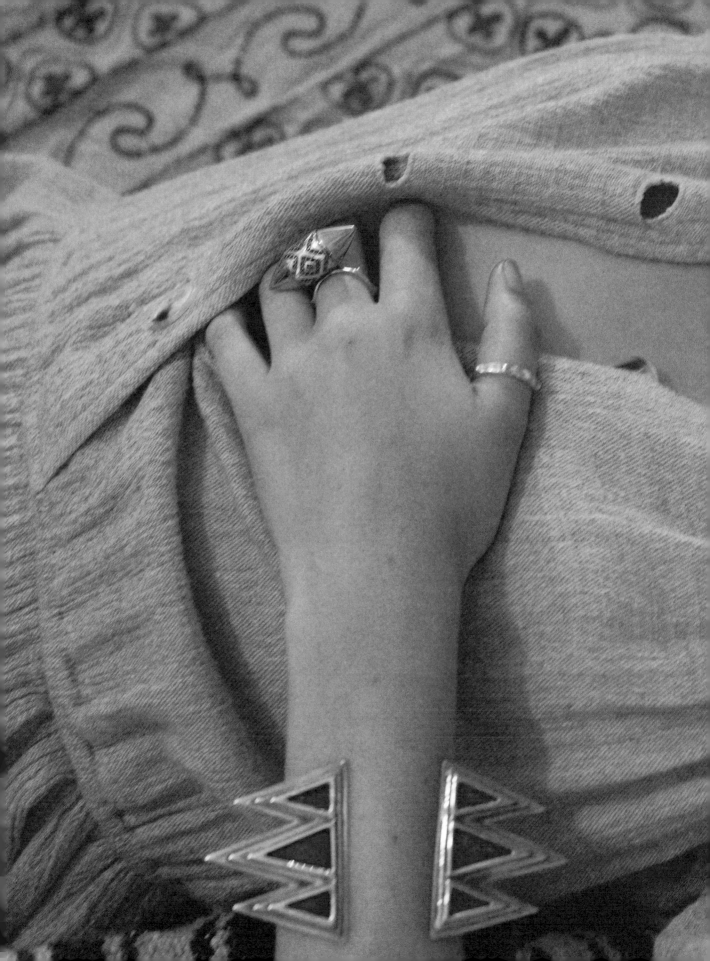

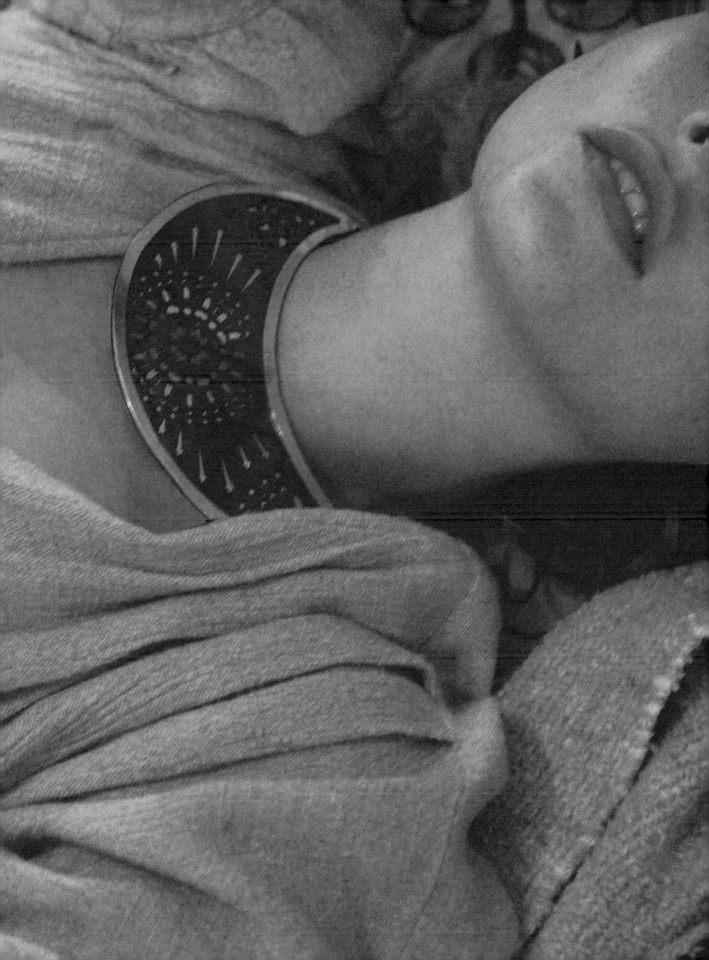

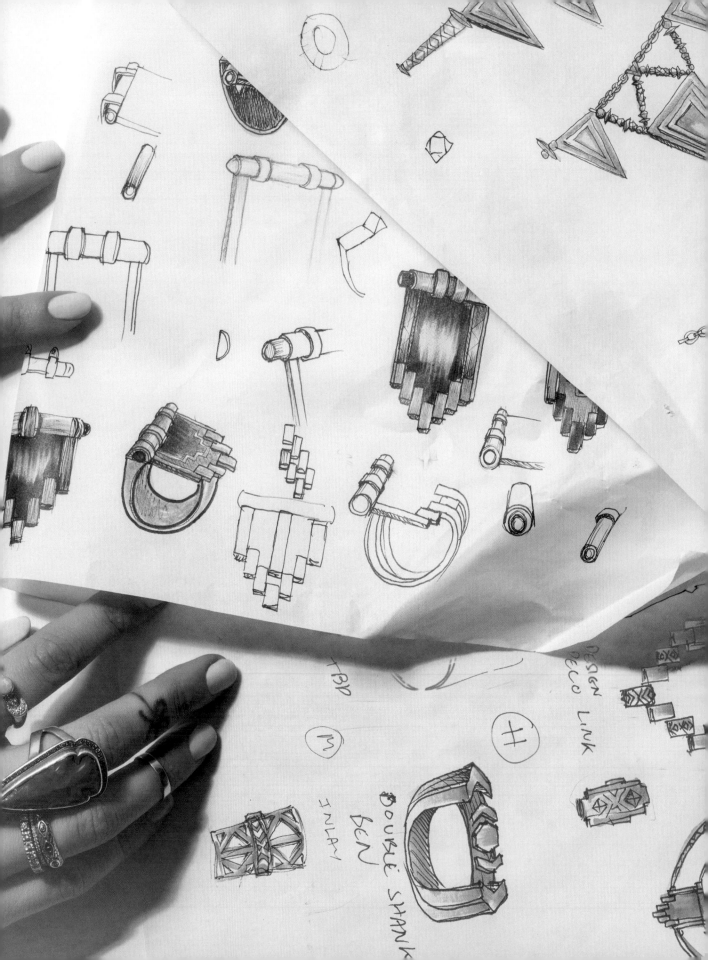

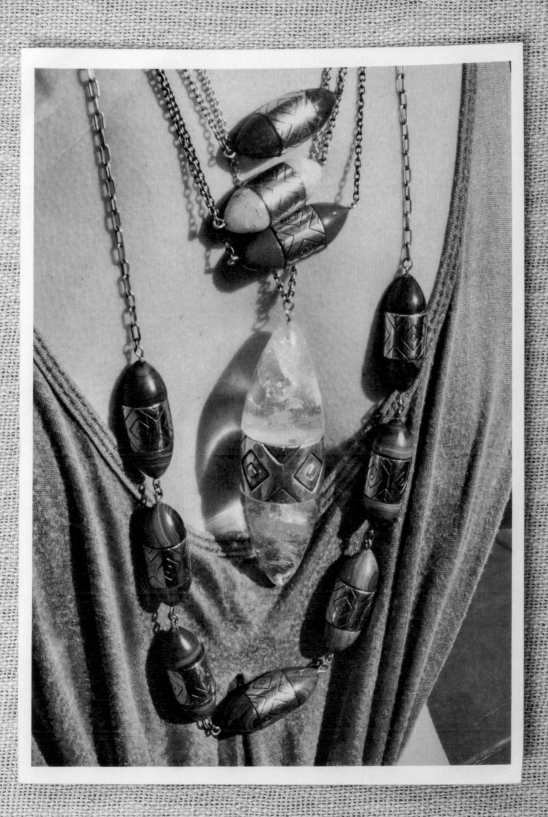

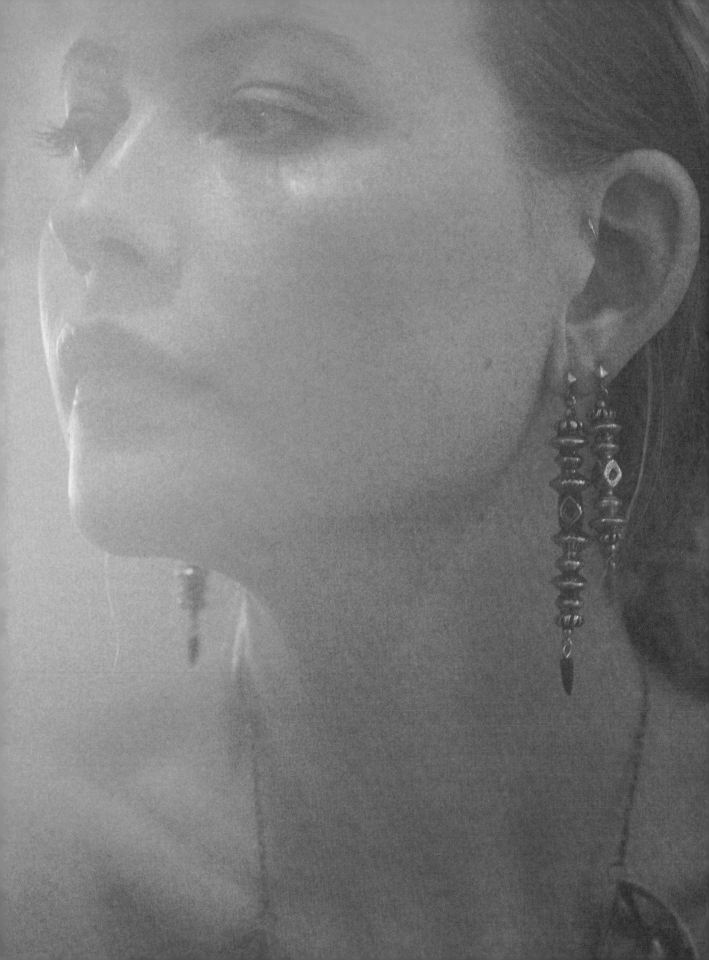

I thought of the wilderness we had
left behind us, open to sea and
sky, joyous in its plenitude and
simplicity, perfect yet vulnerable,
unaware of what is coming,
defended by nothing,
guarded by no one.

—Edward Abbey

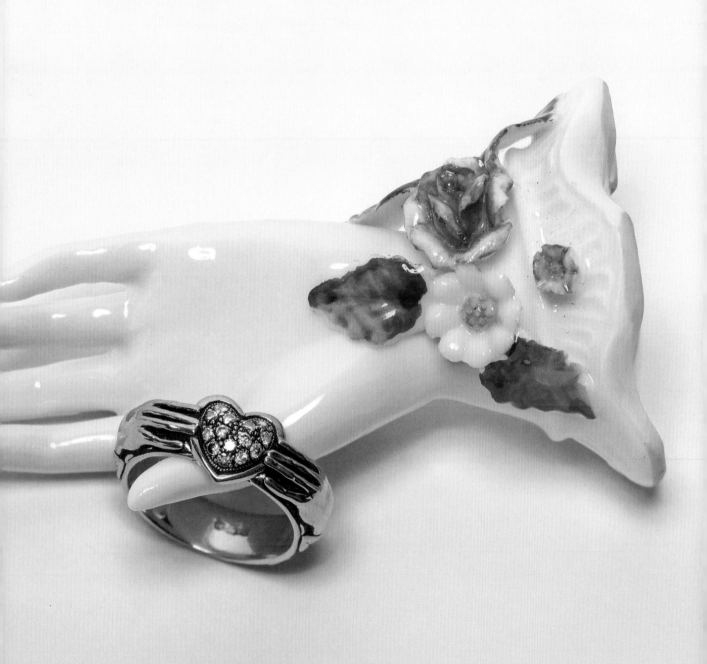

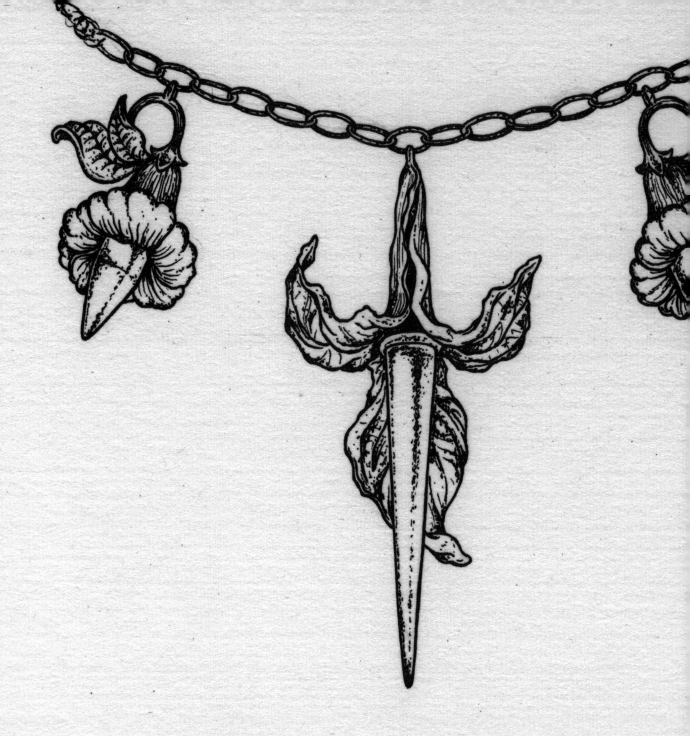

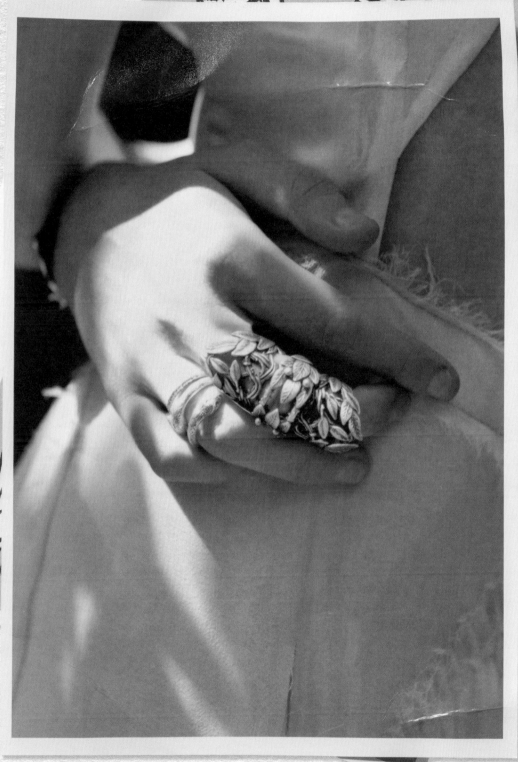

es of growth,
s the beauti-

velop into

terpillar

ch has

oon,

er-

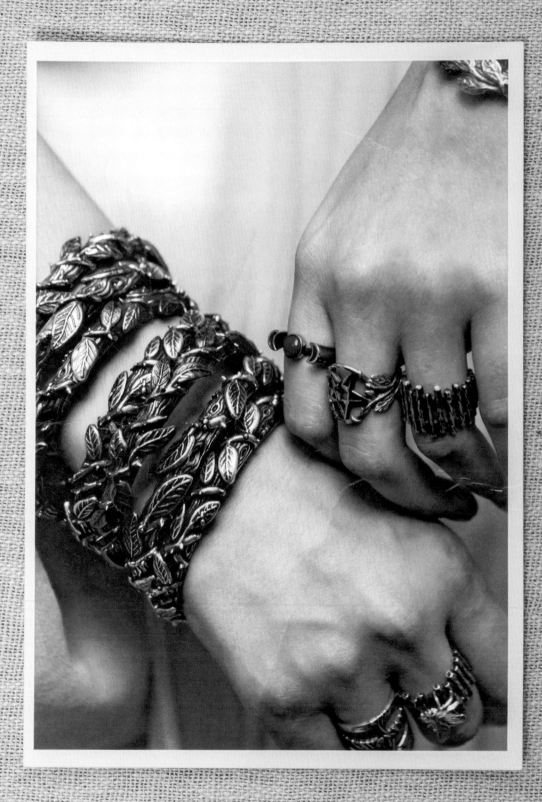

LE COQUELICOT

LA FLEUR

LE BOUTON

2 sépales
libres

étamines

COUPE DE LA FLEUR

nombreuses
étamines libres

stigmates

ovules

ovaire

pédoncule

graines

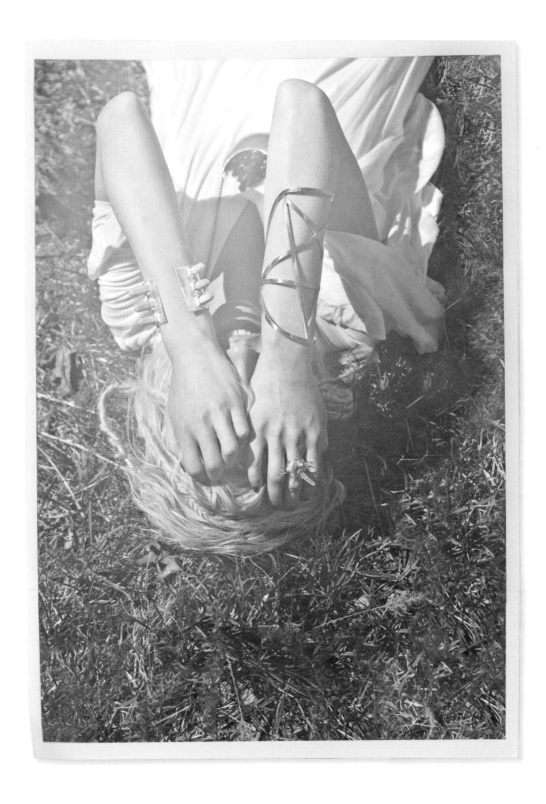

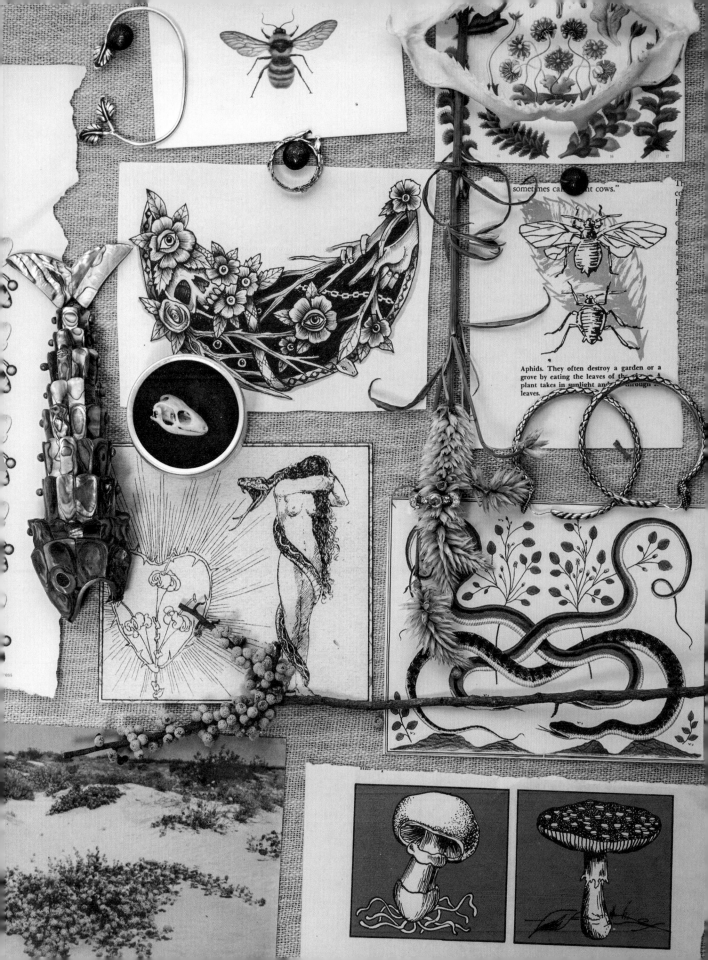

sometimes ca_ _nt cows."

Aphids. They often destroy a garden or a grove by eating the leaves of the _____. plant takes in sunlight an_ __ _rough leaves.

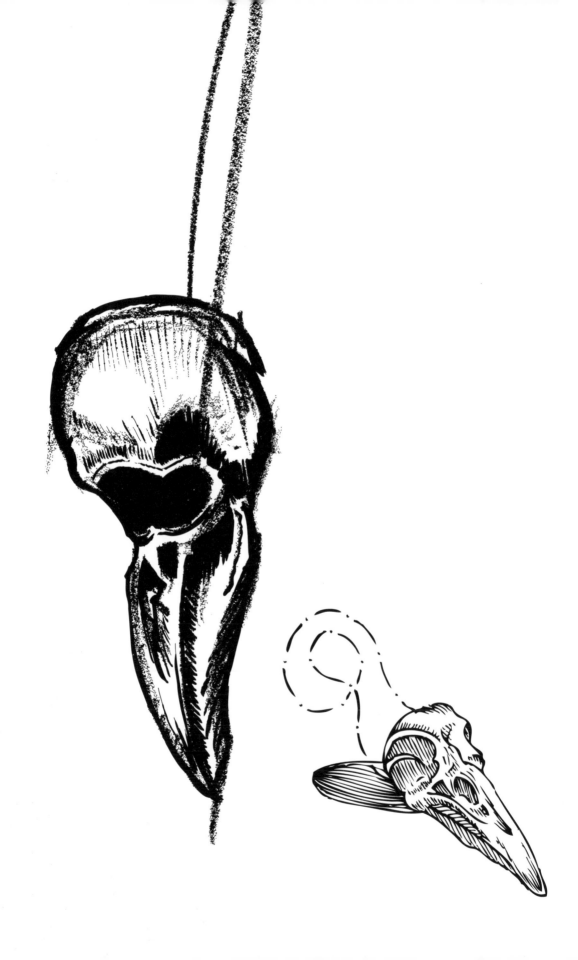

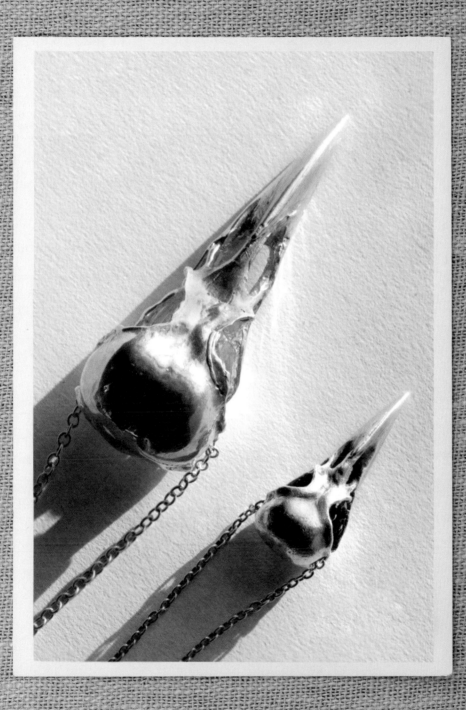

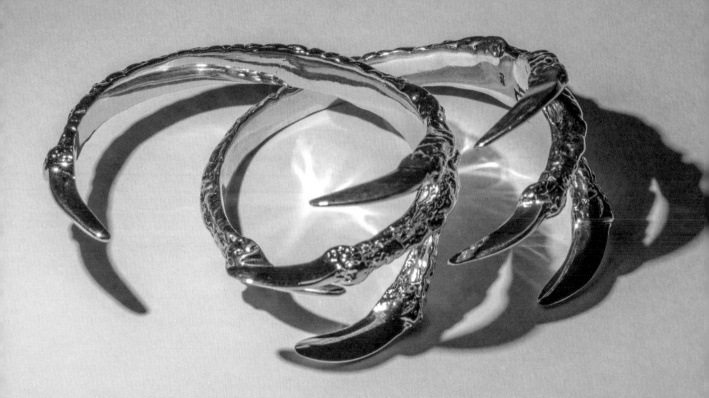

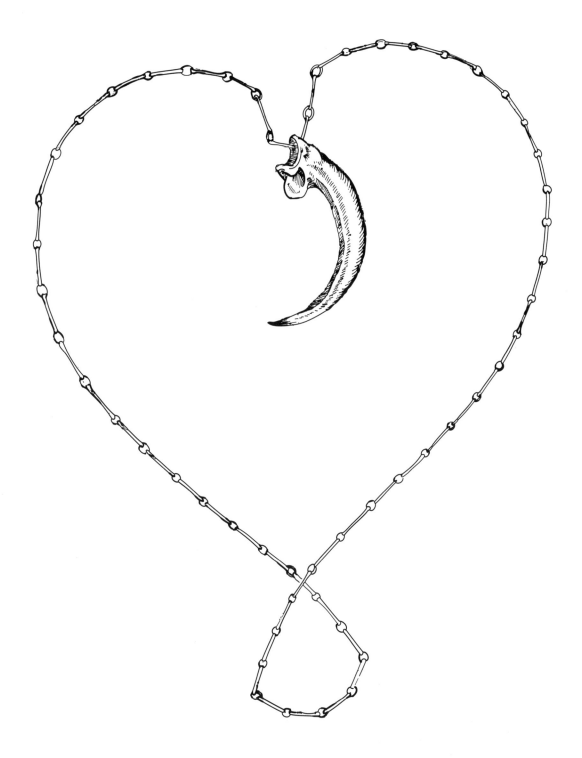

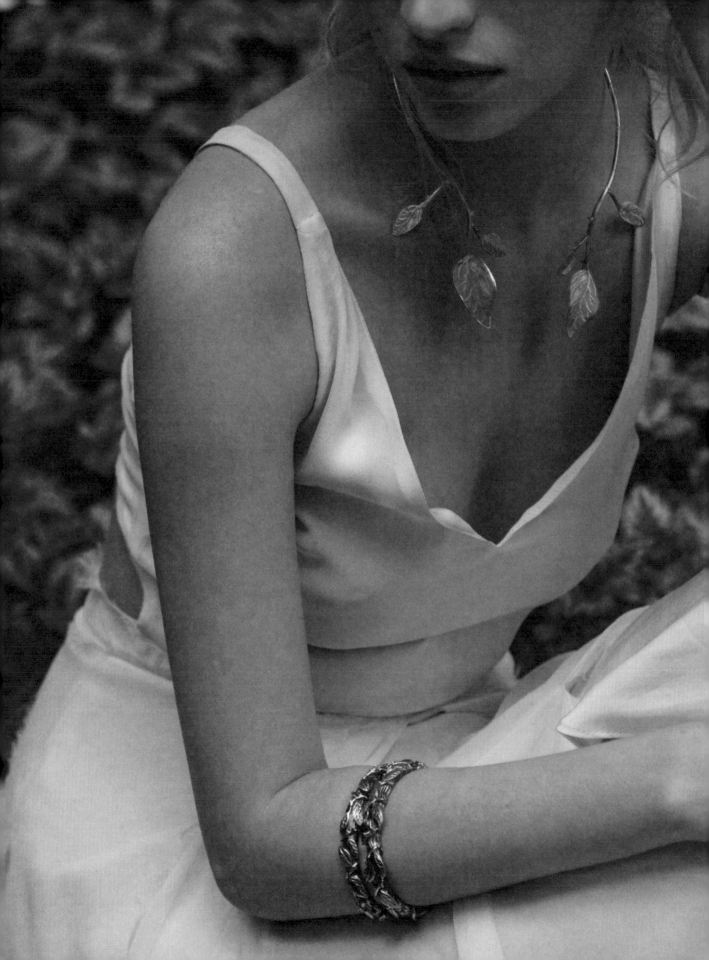

Francesco Clemente, *Emblems of Transformations 68*, watercolor and miniature on handmade paper, 2014

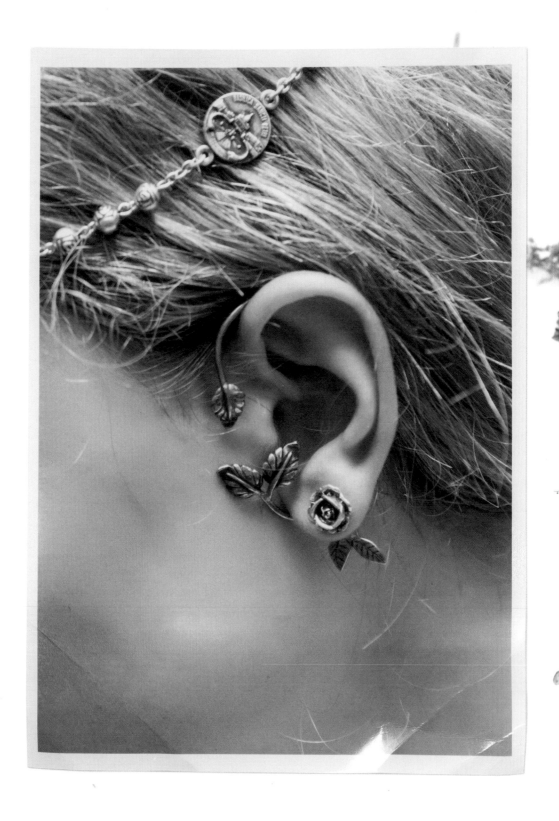

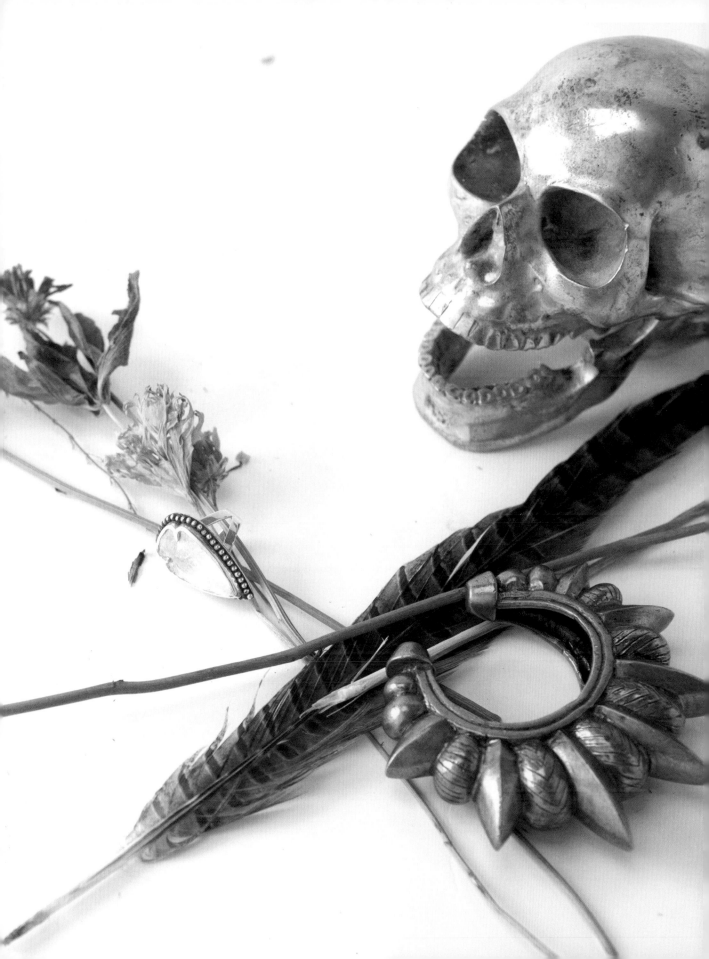

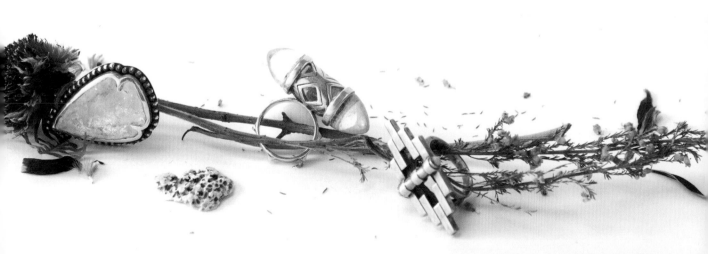

I would like to thank Martynka Wawrzyniak for this amazing opportunity—thank you for being such a fantastic editor (and sometimes a therapist). Thank you to Charles Miers for believing in me and this project and for the wonderful guidance. To Brian Paul Lamotte for being open to my ideas and putting this together beautifully. To my husband, Matthew Nelson Love, for all the love and support and for illustrating my designs perfectly. To Jason Ross Savage for always understanding my vision and making it a reality so effortlessly. To Francesco Clemente for being the ultimate creative mentor and also for his beautiful text. To Ray Siegel for telling my story so well. To Gretchen Jenner for a million reasons. To Krys Maniecki for a million more. To all the photographers, models, artists, and collaborators who helped to make this book come to life, especially Skye Parrott, Ryder Robinson, Harper Smith, Heathermary Jackson, Heather Wojner, Langley Fox Hemingway, Lindsey Wixson, Behati Prinsloo, Charlotte Free, Dorothea Barth Jorgensen, Marina Nery, Agata Danilova, Cheri Bowen, Moe Lamstein, Ian Scott Dorey, Patricia Iglesias, and Teddi Cranford.

To Mom, Josh, and Paul for all of the support.

And, above all, to my PL family: Aldon Pascall, Autumn Casarez, Andrew Turi, Brittany Heaps, Dana Bodourov, Dasha Evdokimova, David Elliot, Gabby Bush, Gretchen Jenner, Guillaume Pajolec, Hambik Yaralyan, Hannah Latimer, Jamie Proust, Johnny Sciortino, Jayde DeLafuente, Krys Maniecki, Mirek Podbielski, Michael Flanagan, Nate Penney, Karen Harvey, Nicole Hendry, Shira Carmi, Susie Saltzman, Sofia Spinnars, Thabata De Barros, Martin Zagorsek and Theresa Lee. Without the jewelry, this book wouldn't exist. And without all of you, I wouldn't be whole.

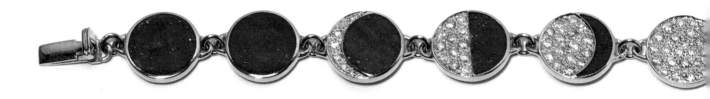

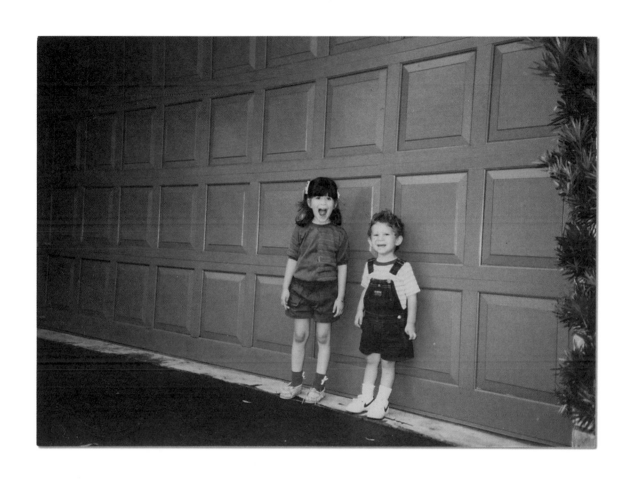

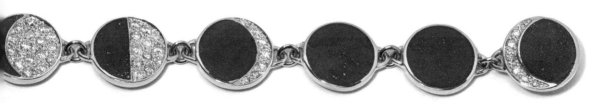

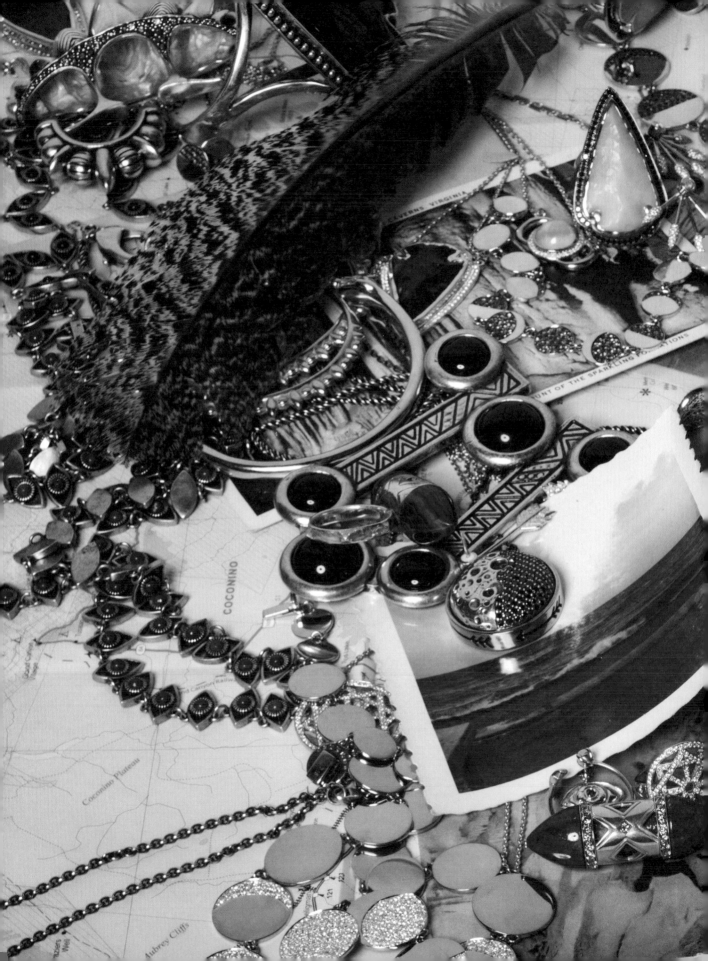

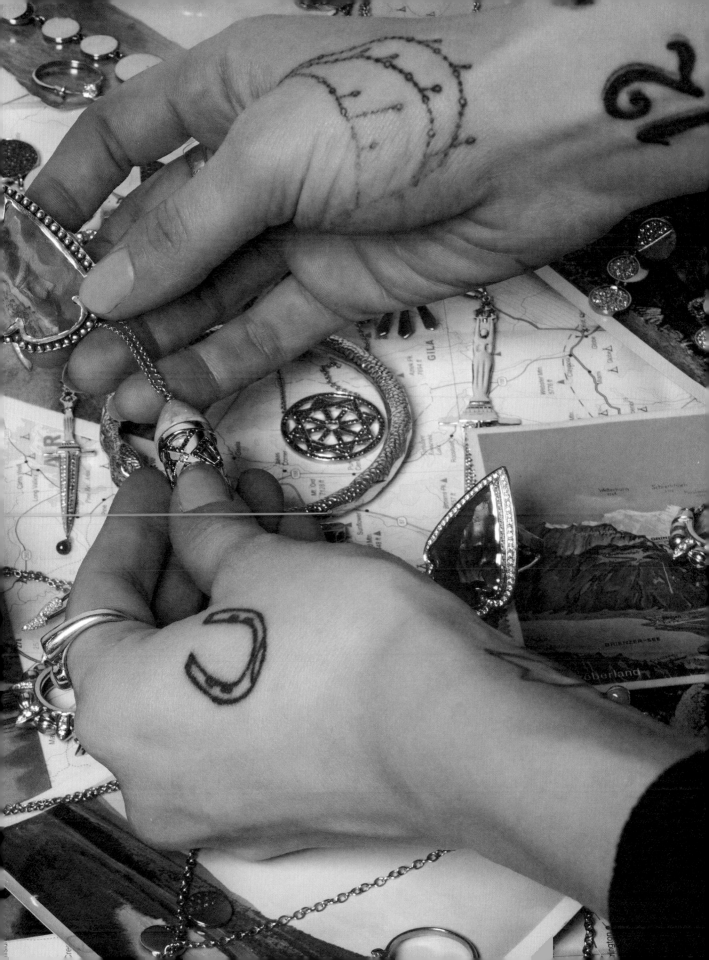

Photography

Zoe Ghertner
Pages: 83 (bottom left), 163

Kat Irlin
Pages: 11, 58 (left), 91 (top left)

Nick Lorden
Pages: 8, 12

Joanna McClure
Page: 102

Georgia Nerheim
Pages: 48, 54–55, 79, 96, 98–99, 105, 169, 170–171

Skye Parrott
*Pages: front endpaper, 24, 33 (top left), 50, 56, 58–59
(top right & center), 61, 64, 67, 70–71, 90 (middle right),
93, 97, 112–113, 118 (top & bottom left), 134–135, 138,
140–141, 143, 145 (middle left), 148–149, 152–153, 157,
158, 160, 166, 168*

Nate Penney
Pages: 128, 136, 151

The Coveteur *(Jake Rosenberg)*
Page: 51

Jason Ross Savage
*Pages: cover, 2, 4, 6–7, 14, 18, 20, 28–29, 30, 32, 35, 38–39,
42, 44–45, 52–53, 57, 62–63, 66, 68–69, 72–73, 75, 76–77,
80, 81, 84–85, 89, 90 (middle top), 94, 95, 100, 104, 106–107,
108–109, 110, 114, 116–117, 121, 122–123, 125, 126–127,
130, 139, 144 (middle top), 147, 150, 155, 164, 172–173,
174–175, 176*

Johnny Scortino
Page: 91 (bottom right)

Harper Smith
Pages: 22–23, 26–27, 31, 36–37, 40–41, 46–47

Harper Smith for Bona Drag
Pages: 78, 101

Jordan Sullivan
Pages: 86–87

Tim Zaragoza
Page: 83 (middle)

All collages from pages 19–175 photographed by Jason Ross Savage

Illustration

Matthew Nelson Love
Pages: cover, 59 (bottom right), 60, 74, 82, 156

Ryder Robison
Pages: 65, 88, 162, 165

Models

Dorothea Barth-Jorgensen
Pages: 50, 58–59, 70–71, 140–141

Agata Danilova
Pages: 62–63, 68

Charlotte Free
Pages: 67, 97, 160

Langley Fox Hemingway
Pages: 22–23, 26–27, 31, 36–37, 40–41, 46

Marina Nery
Pages: 80, 104

Behati Prinsloo
Pages: 134–135, 138, 145, 148–149, 152–153

Cuba Tornado Scott
Pages: 78, 101

Lindsey Wixson
Pages: 24, 56, 64

First published in the
United States of America in 2016
by Rizzoli International Publications, Inc.
300 Park Avenue South
New York, NY 10010
www.rizzoliusa.com

© 2016 Pamela Love

Texts © 2016 Francesco Clemente
& Ray Siegel

Design — Brian Paul Lamotte
Editor — Martynka Wawrzyniak
Retouching — Jason Ross Savage
& Krys Maniecki

2016 2017 2018 2019 / 10 9 8 7 6 5 4 3 2 1

Distributed in the U.S. trade
by Random House, New York

Printed in China

ISBN:
978 0 8478 4819 5

Library of Congress Control Number:
2015942842